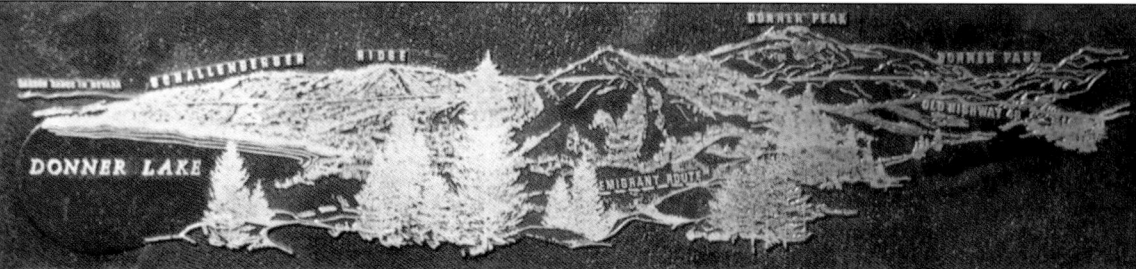

This plaque was installed above Donner Lake at the Victory Highway bridge dedication in 1925. It addresses the struggles of the Donner Party as well as some of the engineering feats necessary to bring both the transcontinental railroad and this transcontinental highway over Donner Pass, connecting both coasts.

ON THE COVER: Steam-powered winches, known as donkey engines, were used throughout the region in the late 1800s. With the advent of narrow-gauge railroads, donkeys were used to drag logs to landings to be loaded onto railcars. This donkey was used in the Tahoe Basin as part of the Hobart logging operation that fed logs to the Virginia City mines before the mill moved north of Truckee.

IMAGES of America
TRUCKEE

Sherry E. Jennings

Copyright © 2011 by Sherry E. Jennings
ISBN 978-0-7385-7495-0

Published by Arcadia Publishing
Charleston, South Carolina

Printed in the United States of America

Library of Congress Control Number: 2010940451

For all general information, please contact Arcadia Publishing:
Telephone 843-853-2070
Fax 843-853-0044
E-mail sales@arcadiapublishing.com
For customer service and orders:
Toll-Free 1-888-313-2665

Visit us on the Internet at www.arcadiapublishing.com

*To my father, Fred E. Jennings (1919–2005),
who inspired me to write from my heart*

Contents

Acknowledgments		6
Introduction		7
1.	The Early Years	9
2.	Getting Business Done	33
3.	Connecting Coasts via Rail	55
4.	Logging the Sierra Hills	73
5.	Ice Harvesting Becomes a Key Industry	81
6.	Floriston's Paper Mill	91
7.	Always Room to Play	97
8.	Going Mobile	117
Bibliography		127

Acknowledgments

There are really two communities to thank for support on the Truckee project. My Truckee family includes Nelson VanGundy, all-around mentor, who made the connection with Arcadia; Win Crowell, who provided me a mountain home-away-from-island-home as well as Floriston images; and Mike and Jen Trombetta, who fed me with outstanding food and friendship.

My Whidbey Island family let me sneak away for weeks on end at times. Thank you, daughter Lily, who I hope I inspired to embrace her inner writer. The project was a wrap, with sanity, thanks to the endless support of Alan Chalfant, Kim Rossi, Colleen Keefe, Russell Sparkman, and Sandi Smith.

A huge thank-you goes out to the Truckee-Donner Historical Society (TDHS) for their never-ending support and encouragement. Without their support, this project would never have come to fruition. Images in this book are courtesy of TDHS, which includes images from many collections. Several images of the Floriston Mill are courtesy of Win Crowell.

Introduction

With visions of the promised land awaiting them to the West, wagon trains, trappers, and miners set across the United States in the 1840s, not knowing what lay ahead for them. The first wave of settlers who sought gold at Sutter's Creek blazed a path along the emigrant trail in Northern California. Many followed, looking to cash in on the opportunities in this gold mecca. Explorers such as John C. Fremont and Kit Carson navigated mountain routes and walked the rim of Lake Tahoe, the banks of the Truckee River, and the shores of Donner Lake. They opened passages across the steep faces of the range that dominated the western horizon.

What many settlers did not quite envision was the vast amount of terrain to be covered. It wasn't just the enormity of the land around them, but also the combination of the terrain and the harsh winter climate. After having managed the long trek across the deserts, negotiating their passage with native tribes, travelers met the last great obstacle to westward travel—the Sierra. Many stories have been told of the trials of the Stephens-Townsend-Murphy Party, best known as the Donner Party, and the nightmarish winter of 1846–1847. The mettle of pioneers such as these is forged into the area's towering granite; their tenacity and toughness lay the foundation for the area now known as Truckee, California.

Without the transcontinental railroad, Truckee would not exist. The decision by Central Pacific Railroad's surveyor and chief engineer, Theodore Judah, to convince the Central Pacific's Big Four—Leland Stanford, Charles Crocker, Mark Hopkins, and Collis P. Huntington—to extend their railroad from Sacramento to connect with the Union Pacific moving west changed history. He chose passage over the 7,000-foot Donner Pass, forever changing the face of the surrounding mountainsides and valleys. The first transcontinental railroad made it possible for westward expansion, changing the history and social structure of the west and the rest of the country. In addition, it set the stage for incredible engineering feats and American industrialization.

When supplies for the railroad were taken along the Dutch Flat–Donner Lake Wagon Road, Truckee's founding fathers struck their land claims along that route. Joseph Gray, a successful businessman, was the first to build a cabin alongside the Truckee River. Gray's Toll Station came into being in 1863 and lasted until S.S. Coburn moved in down the road with a larger settlement. Coburn's Station, chosen as the advance camp for the railroad, existed until residents called for a change of the town name in 1868, at which point Coburn's Station became Truckee. When fire broke out shortly after the name change—burning 50 buildings to the ground—a new Truckee, complete with more than 300 buildings, was built seemingly overnight.

The rough-and-tumble mountain town consisted of saloons and restaurants, hotels, mercantile shops, butchers, grocery stores, theaters, churches, lumberyards, a school, and livery stables. It also had its less respectable forms of commerce, such as the prostitution on Jibboom Street and the Chinese opium dens.

What started as an experiment by Charles Crocker of the Central Pacific's Big Four turned into one of Truckee's darkest moments: the anti-Chinese movement known as the Truckee Method. After harsh winters and labor strikes slowed progress on the construction of the railroad, Crocker chose to hire cheap Chinese labor to help finish the tracks to Promontory Point. What began as 12 workers ended with 10,000 Chinese laborers working feverishly on the railroad. The Chinese weren't afraid to work, stayed mainly to themselves, didn't drink or fight, and were dependable labor. They chose not to assimilate to American culture, which left a bit of mystery in their wake. After the railroad was completed, the Chinese stayed in the area, working at lumber mills, the railroad, contracting coal production and wood milling, and providing labor to the hotels, restaurants, and anyone else who would hire them.

However, beginning as early as 1875, animosity flared when work at the mills and in the ice industry slowed. Several fires that started in Chinatown and threatened Truckee proper escalated the friction between the whites and Chinese. The white workers were resentful of the cheap labor and sought to rid the area of the Chinese. Early attempts to do so ended with tragic consequences. The Chinese were forced to move across the Truckee River on the south side of town after they were burned out of their homes, and white groups such as the Caucasian League headed up a boycott movement to remove the Chinese permanently from the Truckee area. The boycott sought to punish any business that used Chinese labor.

Charles McGlashan headed this movement, traveling the West Coast to gain support for his cause. One vigilante group, the "601"—which stood for six feet under, zero questions, one bullet—took matters into their own hands and committed brutal acts against the Chinese. Purely racist in nature, the infamous "Truckee Method" left the town divided. In the late 1880s, the Chinese were driven from Truckee and transported to both coasts, where many were left puzzled as to how Truckee could be so intolerant.

During the construction of the railroad and the extension of the mines in Virginia City, Truckee's lumber mills flourished. As more and more settlements popped up, the demand for timber increased. Once the railroad was built, a whole world of opportunities came about. Wood from mills such as Hobart, Schaffer, Boca, and Truckee was shipped to Sacramento and San Francisco. Boca Brewing Company shipped its famous beer around the world. The Floriston Mill, opened in 1900, manufactured wrapping tissue for California's produce exports. The booming ice-harvesting industry changed the way that produce was shipped, mines were cooled, and people drank beverages. The railroad morphed with the innovations, designing refrigerated cars and freight cars to ship specific goods and to cater to the human freight now moving freely across the country.

All of these innovations changed the state's economic outlook when gold and silver mining waned, but there was one idea that forever changed Truckee—winter sports. As the economic climate in Truckee was declining with the dwindling of the logging and ice industries, an early snowstorm got Charles McGlashan thinking. He believed that by giving Truckee-bound train passengers something to do when they disembarked in the winter, Truckee's economy would get a well-needed boost. When Truckee built its first ice palace smack in the middle of downtown in 1896, complete with an ice-skating rink and toboggan run, people started taking the train to Truckee to enjoy these new diversions.

The first ice palace spawned a second ice palace and the annual winter carnival that drew more than 10,000 people each year. Dogsled races followed along with sleigh rides and, ultimately, skiing. It is said the country's first ski lift was built here. With improved roads, winter recreation took hold. Today, the Truckee area is known for its world-class ski areas and winter fun.

Between 1850 and 1920, Truckee bustled with an excited pioneer spirit. A great diversity of people settled here, including cattlemen and lumbermen, miners and icemen, railroad engineers and laborers, chefs and salesmen, educators and lawmen, politicians and publishers, and papermakers and outdoor adventurers. Although lawless at times, the small town of Truckee made monumental efforts to support the advancement of our country through its collective spirit. Today, those who come to Truckee to live and conduct business share in that spirit. Although an interstate highway runs through town and railroad operations are flawless, there is still a mountain community that must work together with its diverse community. Truckee is an official California Welcome Center; unofficially, it has been welcoming people for more than 150 years.

A Paiute chief is to be thanked for Truckee's name. In the mid-1800s, this chief helped many settlers and explorers through the area and across the Sierra. When he came upon one party of travelers, he yelled, "tro-kay," a Paiute term for "everything is all right." After he repeated it several times, the group of European settlers thought that he was telling them his name. They started calling him Truckee, and he liked the name so much that he kept it as his own.

The townsmen liked him so much, they adopted his name for the town.

One
THE EARLY YEARS

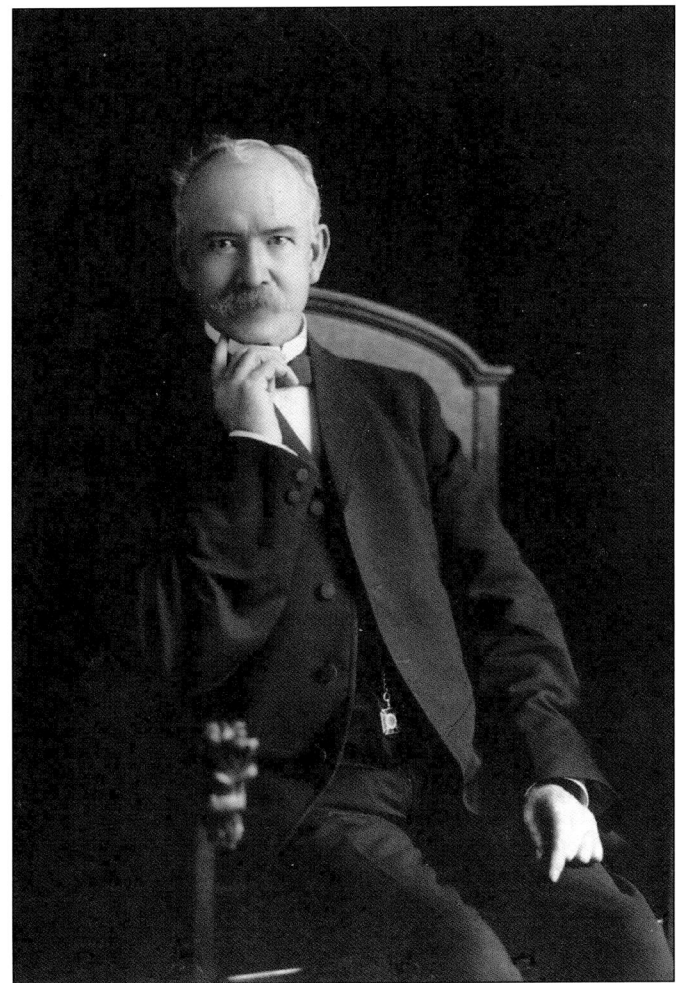

Probably the best-known figure in Truckee history is Charles Fayette McGlashan, a Scottish immigrant who found a home in the Sierra. Arriving in Truckee in the 1860s, McGlashan became the publisher of the *Truckee Republican* newspaper. He was a self-taught attorney, a local historian, and owner of the famous McGlashan ice palace. His forward thinking put Truckee on the map as a winter-sports mecca.

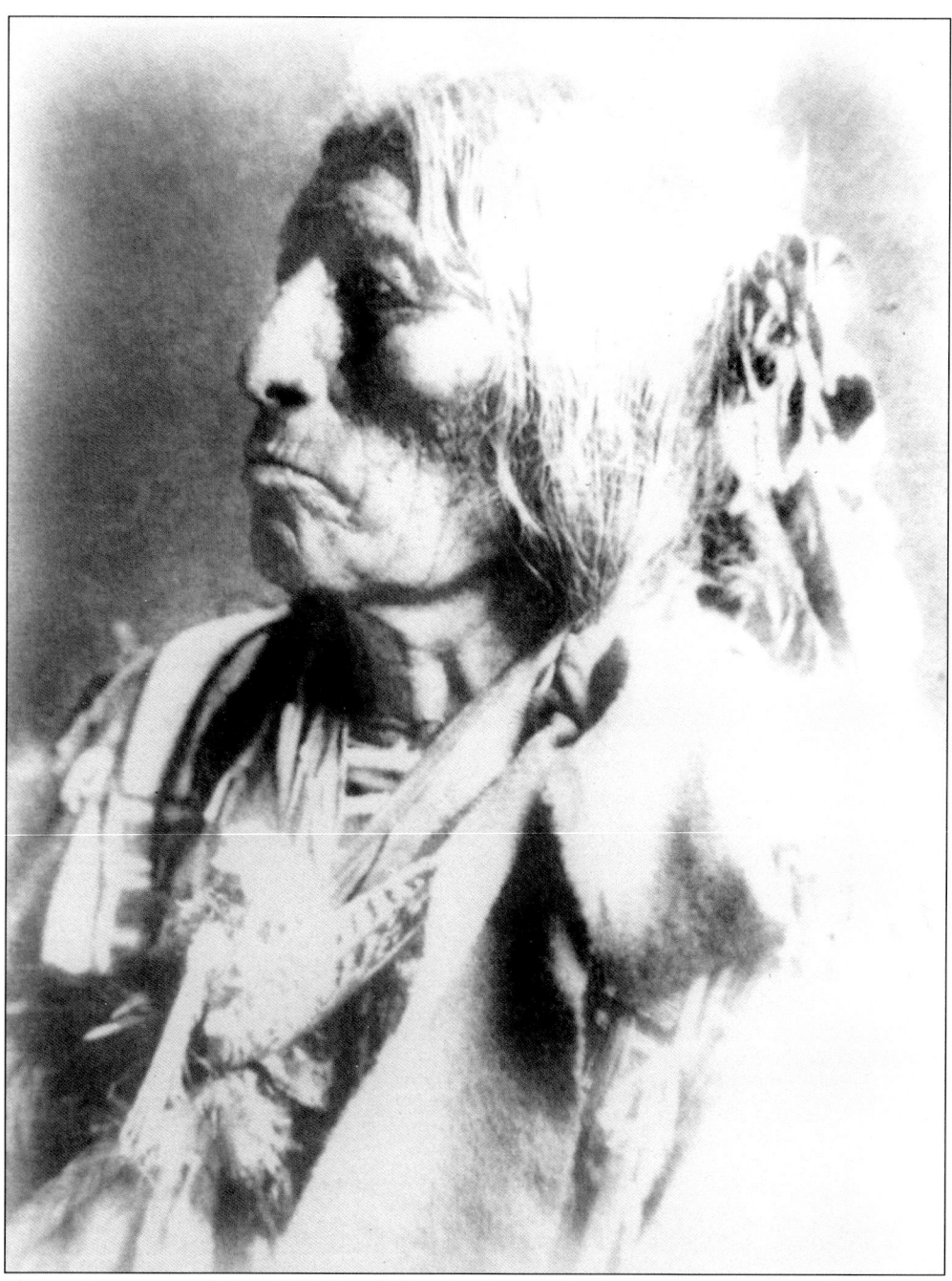

Native Americans inhabited Washoe Valley for thousands of years prior to westward expansion and the gold and silver rushes. While on their way to California, white men encountered both friendly and unfriendly tribesmen. One Paiute chief stood out above the rest. Chief Truckee, known for his kindness, helped thousands of pioneers find their way across the Sierra as a guide. In 1846, Chief Truckee joined volunteer forces with the US Army, ultimately becoming a captain during the Mexican-American War. Commended for his service to the country, he returned to Nevada.

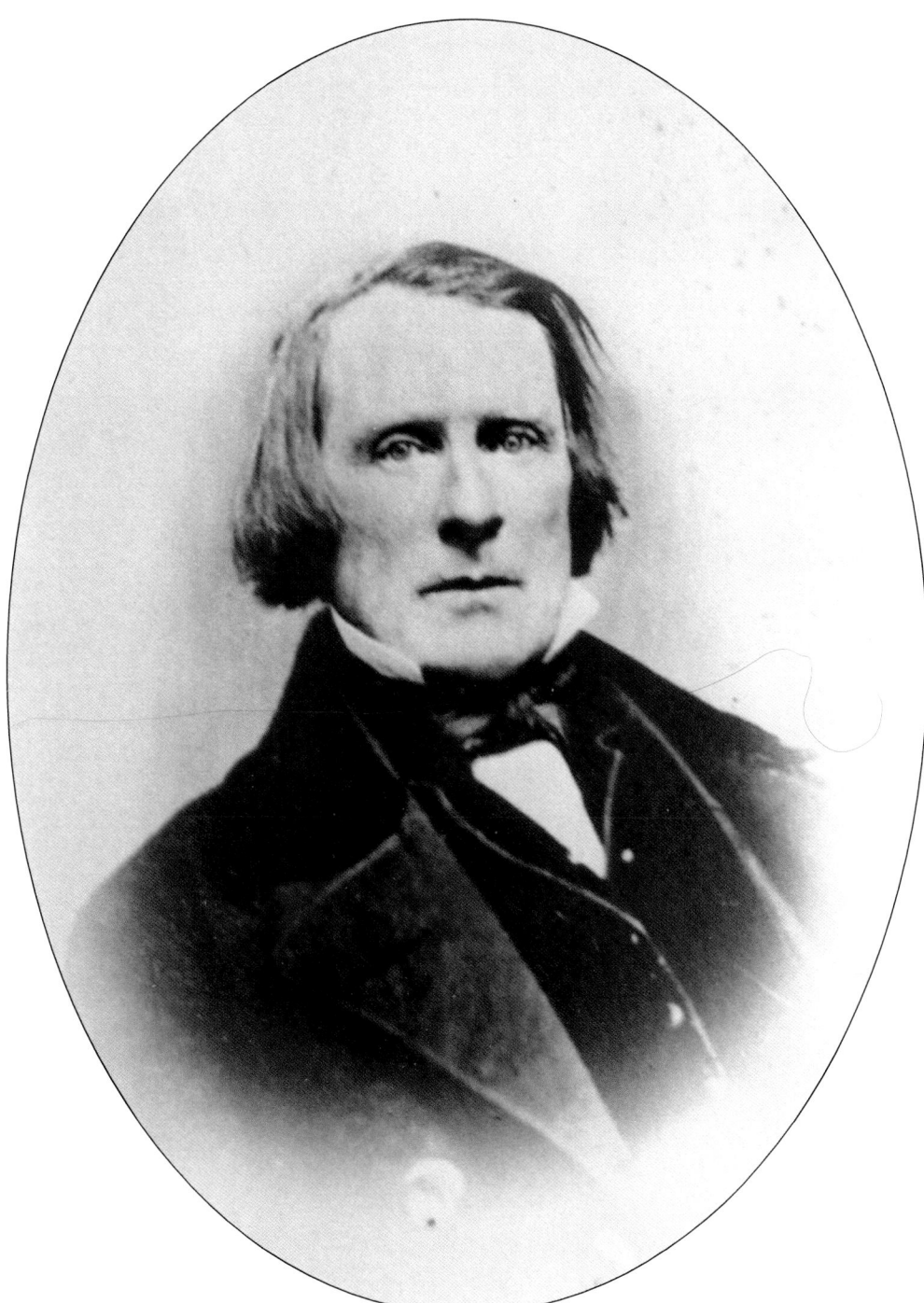

Joseph Henry Gray, born in Durham, England, immigrated with his family to Pennsylvania in the 1820s. The family moved to Iowa and later to Illinois. When a young Joseph became restless and bored, he and his two brothers came over the Sierra by way of Sacramento. In the 1850s, Joseph became the first known white settler in the Truckee area, buying 640 acres along the Truckee River and moving there with his wife, Ann, and their three daughters.

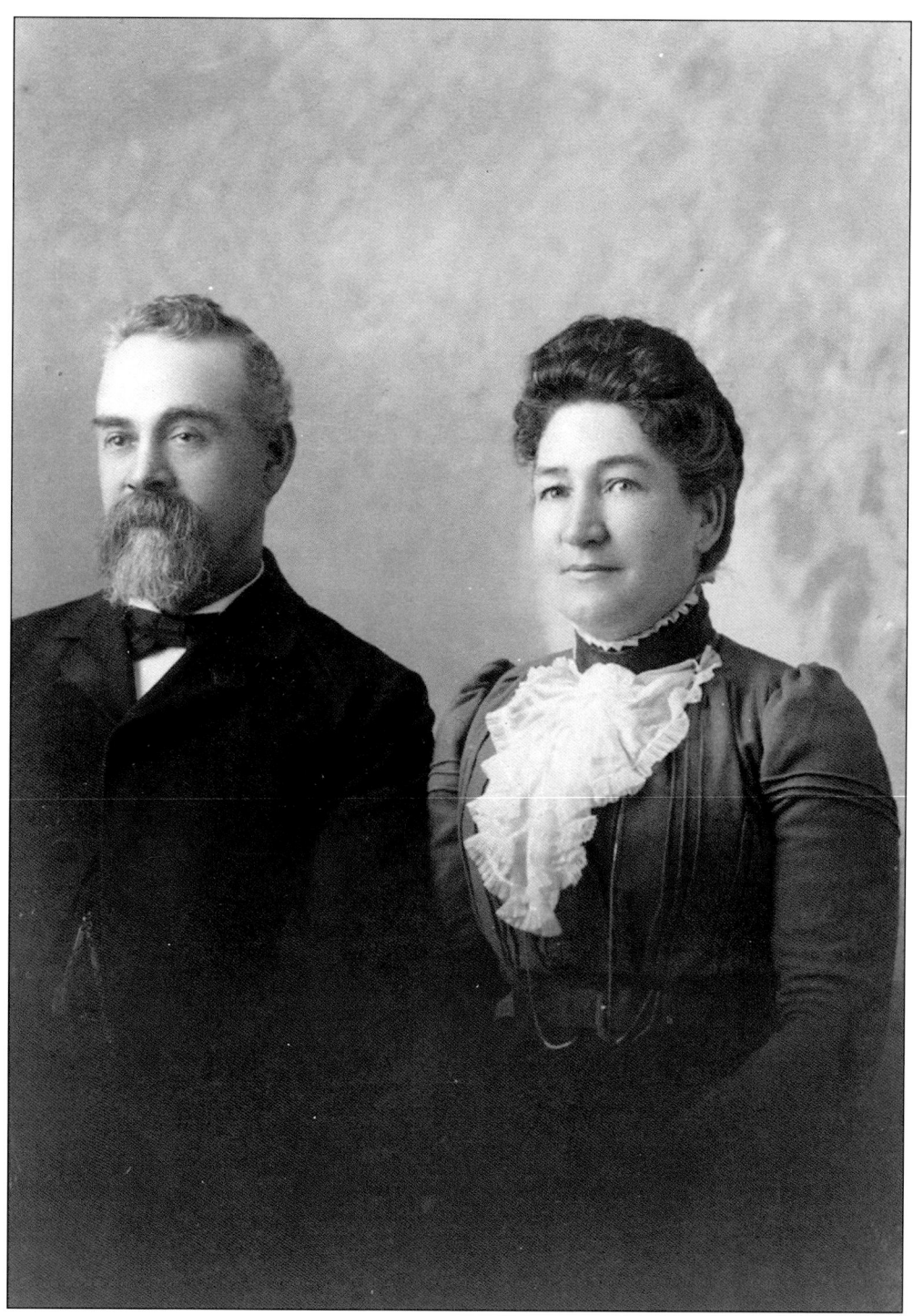
Joseph and Ann Gray managed Gray's Station, which included a cattle operation, freight company, blacksmith, and horse stables. The original Gray's cabin fed hungry cowboys and railroad workers. Just a few months after the Central Pacific engines came through Truckee, Ann and Joseph welcomed their first son, Joseph Henry Gray II, who became the first white child born in Truckee.

In 1858, Joseph Gray built the first known cabin in Truckee. Originally located at the corner of East Main and Bridge Streets, the 24-by-20-foot building was hand hewn of lodgepole pine and tamarack. When the Dutch Flat–Donner Lake Wagon Road was in operation, it ran right past Gray's hostelry. The cabin was moved several times and today is the town's parks and recreation office.

Gray's station was a bustling place along the Dutch Flat–Donner Lake Wagon Road. The original title to the land that Gray purchased encompassed the entire downtown business district. At the time, the land was fenced for his cattle and company horses. He owned the California Stage Company and later partnered with George Schaffer on the town's first sawmill. He also owned Peoples Ice Company.

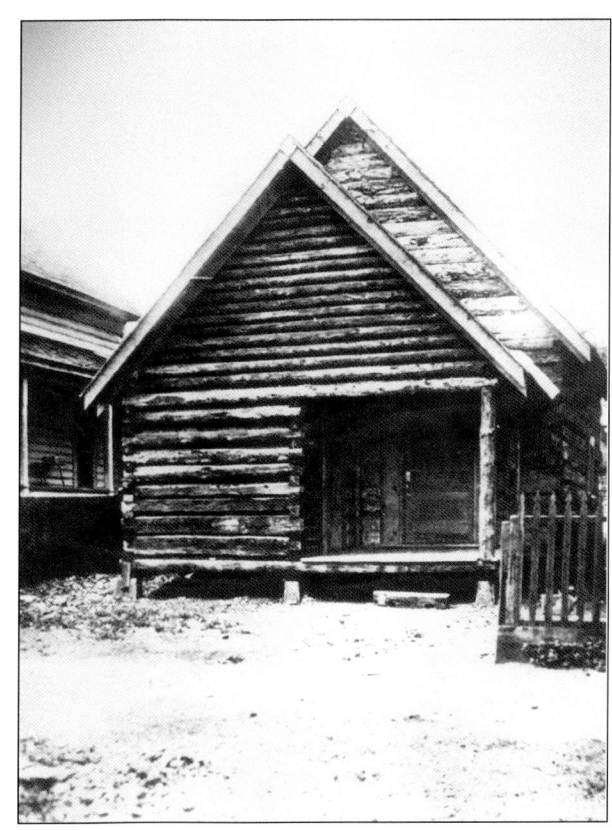

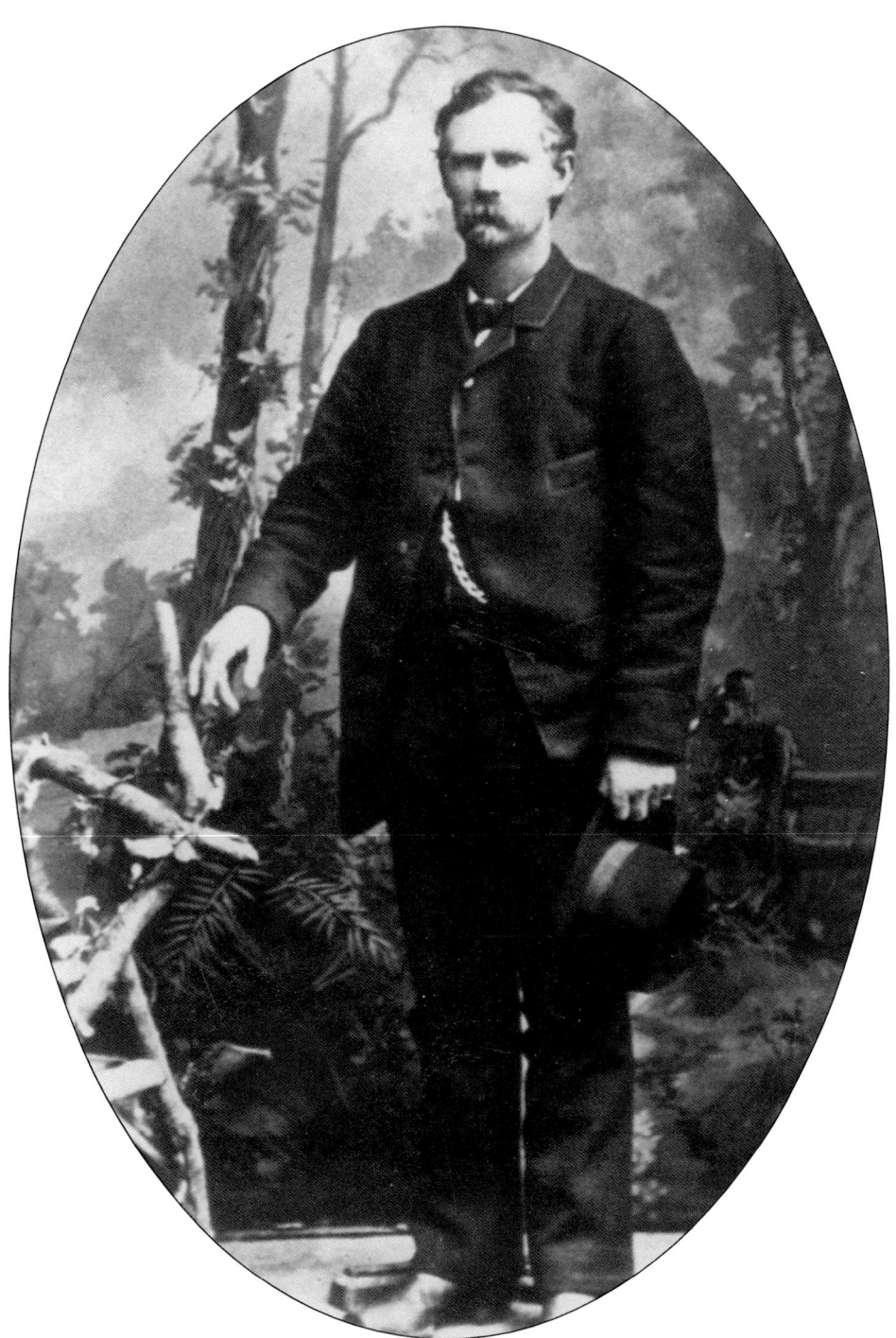

Originally from New Jersey, Jacob Teeter settled down in Truckee and became the constable of the lawless town. Teeter was known as a fair lawman who looked down on vigilantes. His deputy, James Reed, took the law into his own hands, acting with the "601" vigilante group as they sought to rid the town of the "undesirables." A rivalry between the two men ensued, ultimately leading to Truckee's infamous 1891 Teeter-Reed gunfight, during which both men were killed.

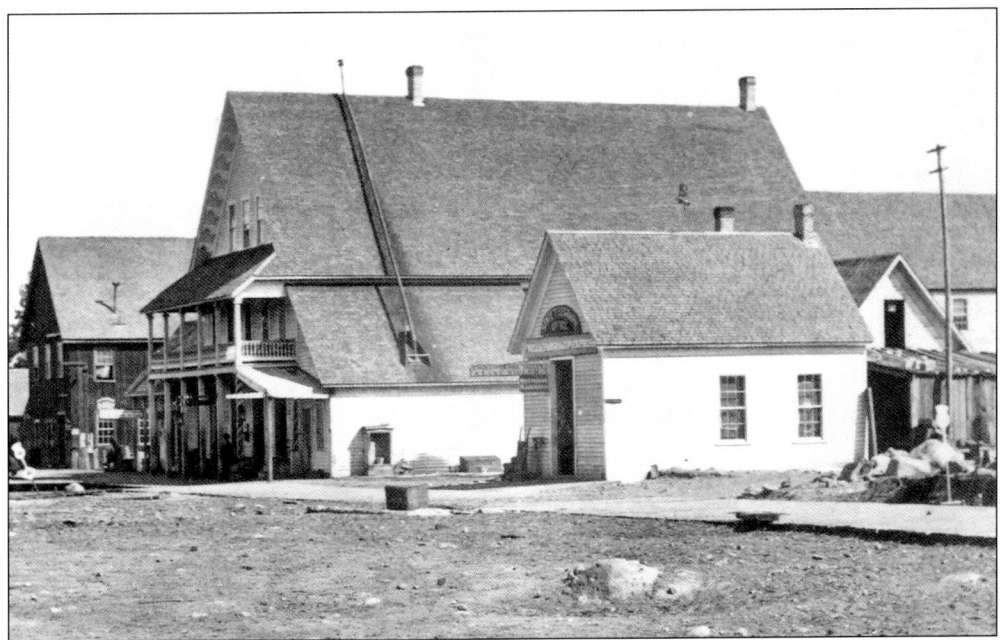
Built by J. Moody, the original Truckee Hotel, captured here in 1873, was located on River Street across the tracks from Main Street businesses. Before its demise and later resurrection, it sat right on the other side of the tracks that brought visitors to Truckee. Before the railroad station was built, this hotel served as the main depot.

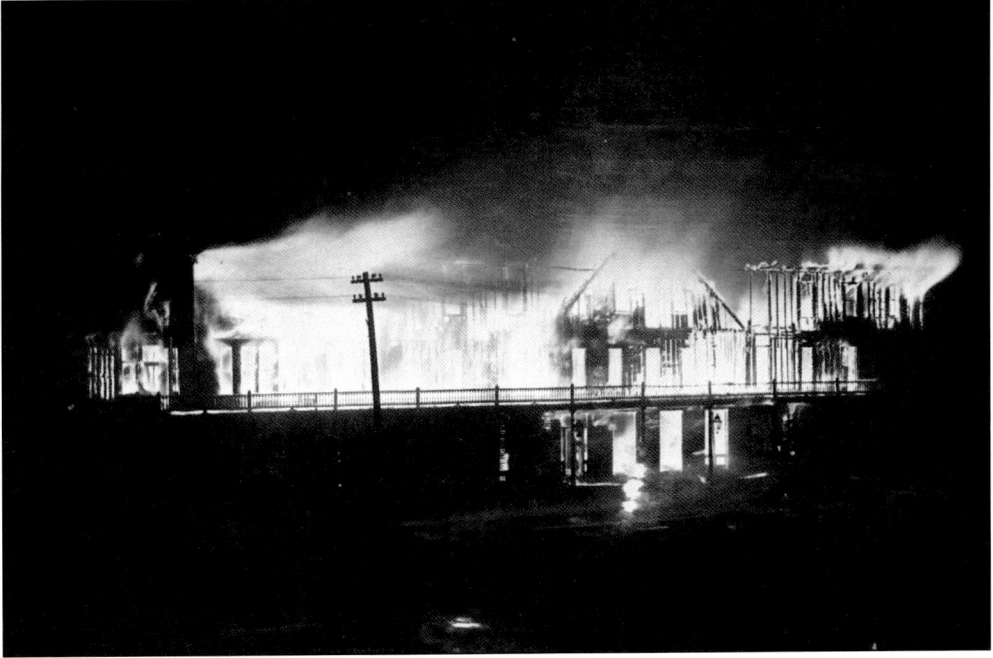
The Truckee Hotel blazes in 1900. Known as one of the finest hotels along the Central Pacific Railroad, the hotel was rebuilt. Most of the fires at the time were blamed on arson, carelessness, or embers that escaped from woodstoves. The Truckee Hotel was later moved to the Whitney Hotel building on Bridge Street.

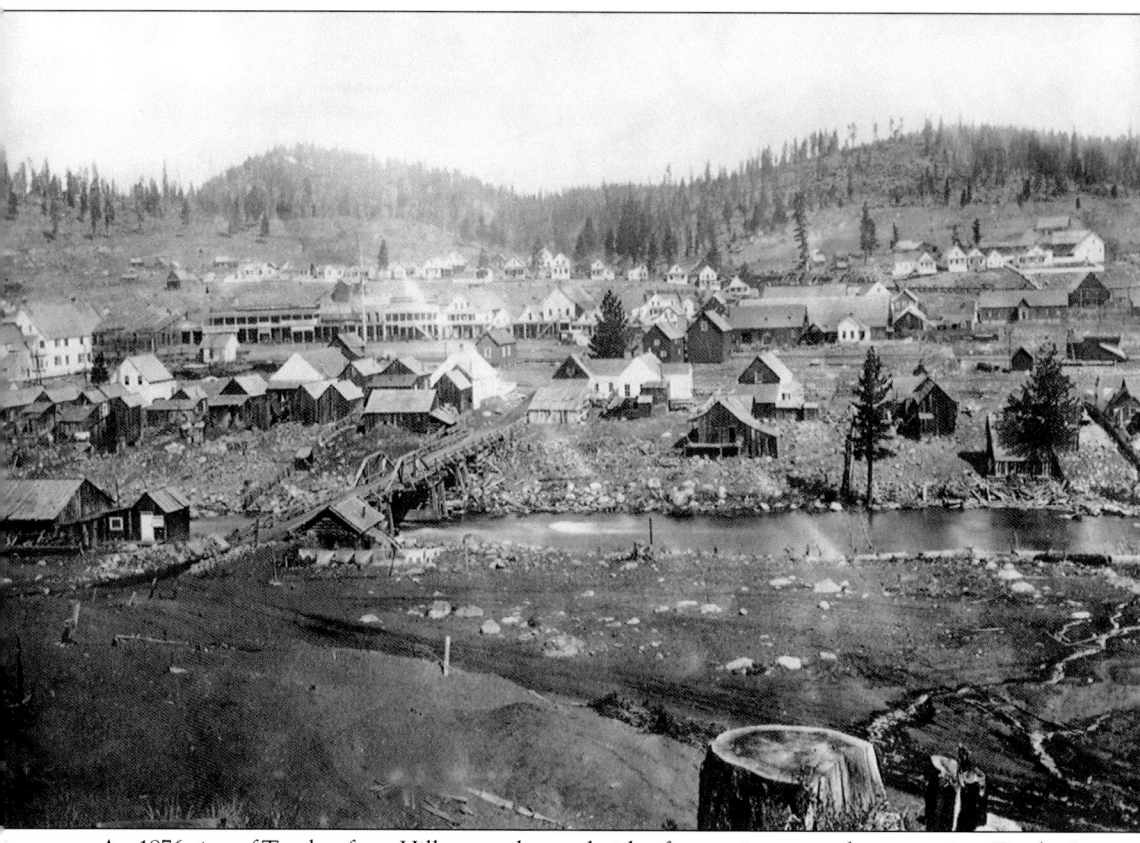

An 1876 view of Truckee from Hilltop on the south side of town gives an early perspective. Truckee's businesses already saw the need, due to snow, for covered walkways. A closer inspection of this photograph reveals the then seven-year-old railroad running through town. The footbridge was later widened for vehicular traffic over the Truckee River. It is apparent that much timber was already taken from the hillsides to build the town.

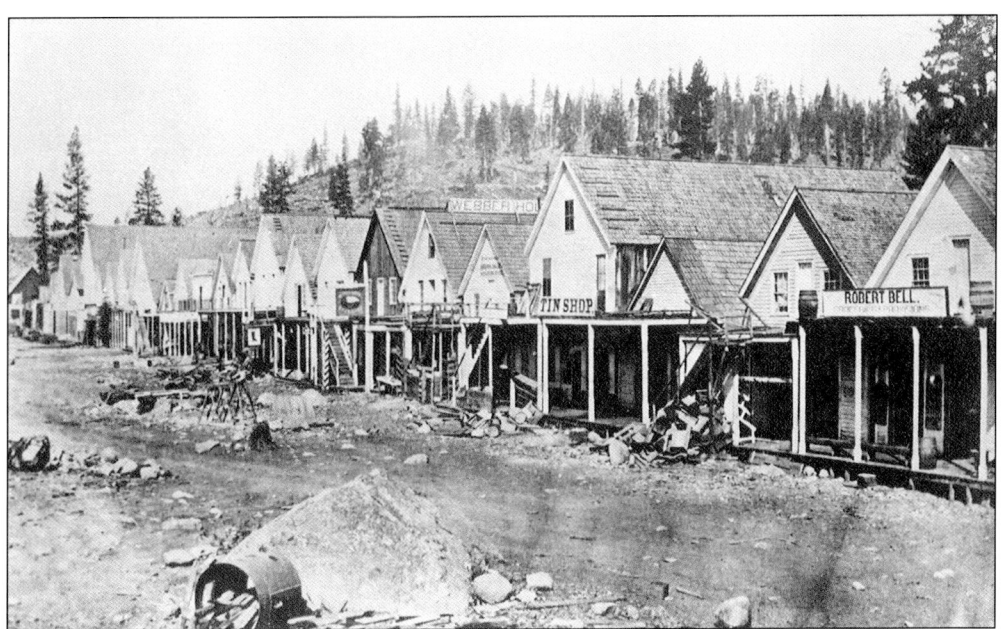

Truckee is born. After a devastating 1868 fire during which more than 50 structures were lost, Colburn's Station was rebuilt and renamed Truckee. This wouldn't be the last fire that roared through town. As fires erupted, more anger against the Chinese was created because whites believed the Chinese were to blame.

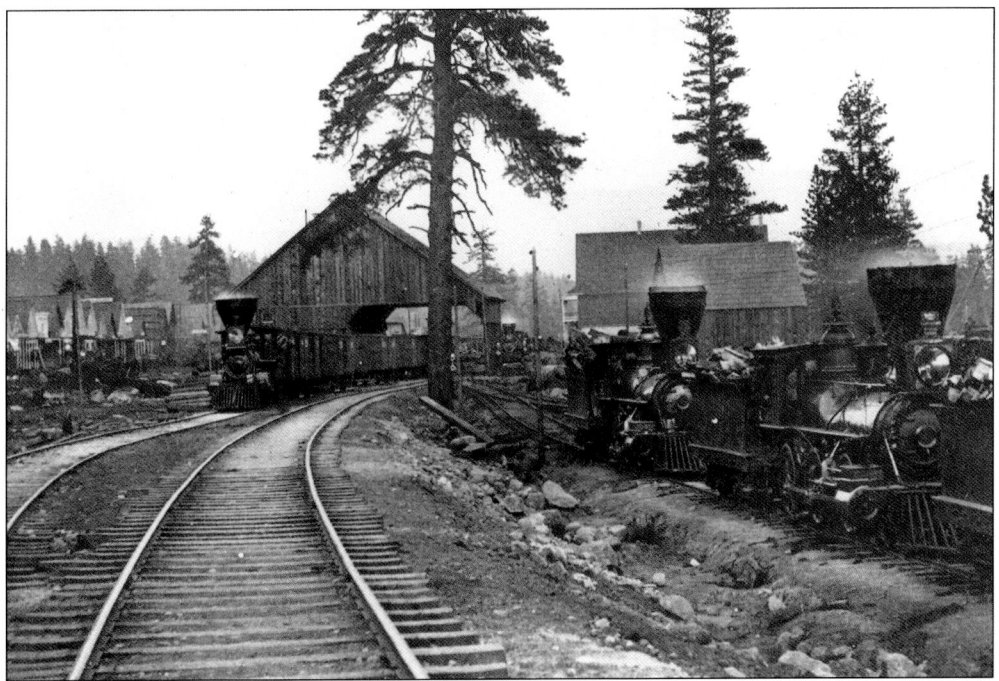

This photograph of the original train station in Truckee was taken in 1869, the same year the transcontinental railroad was completed. Three diamond-stacked steam engines are visible in this photograph. It was shot looking east through town, and the Main Street businesses can be seen on the left. Today's depot was built just east of here.

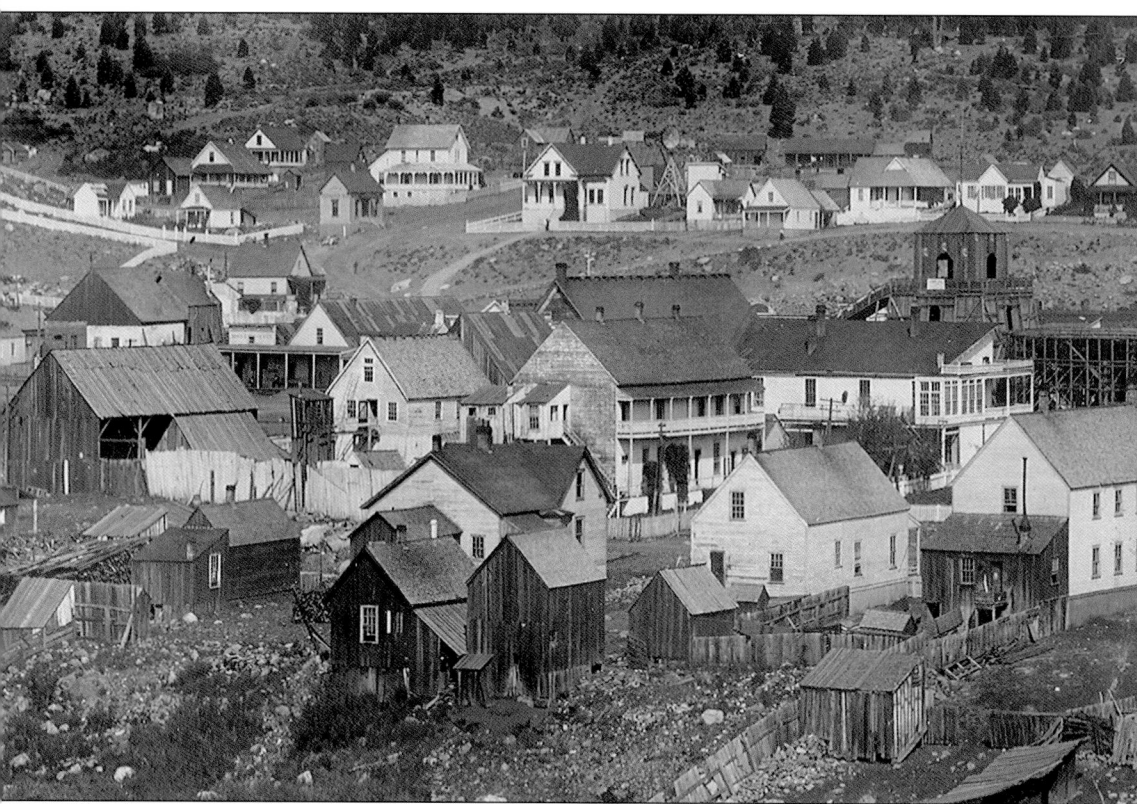

Truckee was developing quickly near the end of the 19th century. Taken from the hillside above the walking bridge, the 40-foot toboggan run tower above the original ice palace juts above the downtown buildings. Also visible are High Street and the back of the Truckee Hotel on River Street. Just out of view is the Rocking Stone Museum.

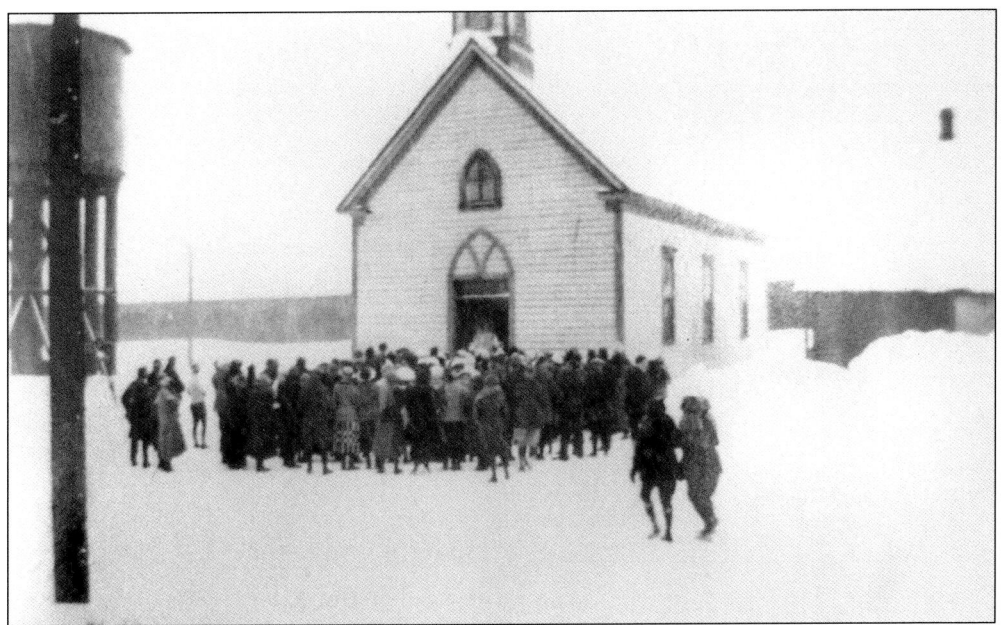

The Assumption Catholic Church hopscotched through its history. In 1869, the church—built for the nearly 9,000 Catholics who worked on the railroad's construction—was located closer to the Truckee Lumber Company. The church was originally constructed near the lumber yard on what became Church Street. It burned and was rebuilt in 1907 in the same spot. The photograph was taken in 1907. The church moved to E Street in 1949 after the state planned to run Highway 89 through the Church Street location.

Just across from Church Street was Jibboom Street, which ran directly behind the Main Street businesses. Jibboom Street was best known for containing the red-light district. Gentlemen easily walked from the back of Main Street saloons to houses of prostitution. Conveniently, the jail was also located on Jibboom Street. This photograph was taken in 1870.

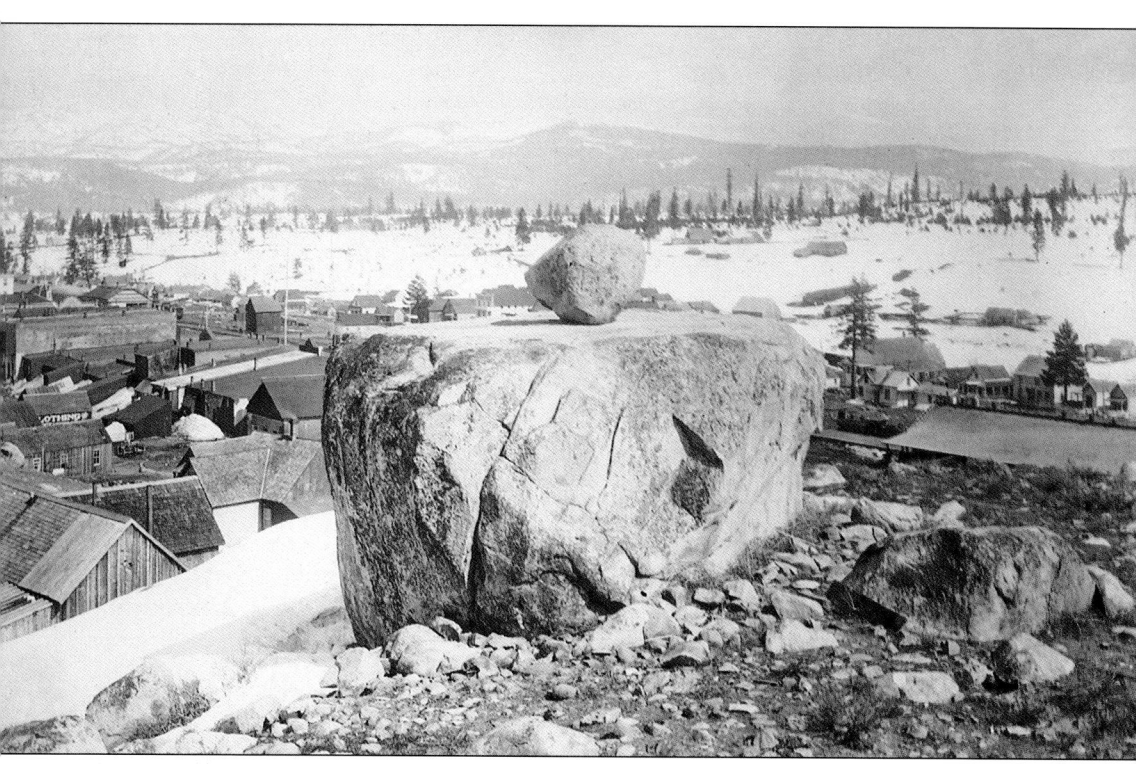

Deposited by glaciers thousands of years ago, the rocking stone above downtown Truckee moved easily under human pressure until the mid-1900s. The stone weighed 17 tons and is one of 25 known rocking stones in the world. Charles McGlashan built a structure around the rock to preserve it. The stone was cemented in place for preservation and is now covered by a gazebo.

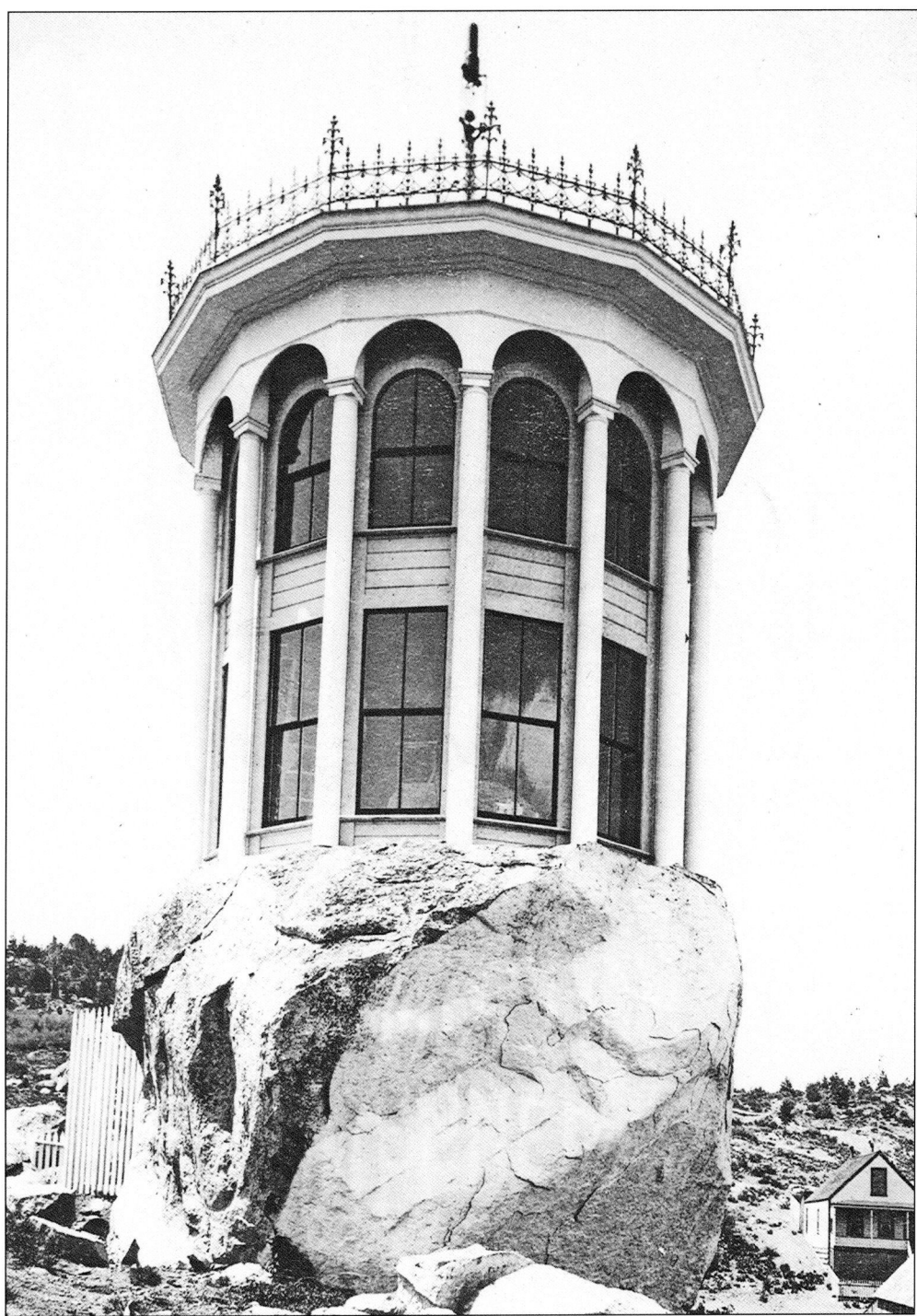

Charles McGlashan built the Rocking Stone Museum on High Street in 1895 to preserve the glacial erratic. The museum also housed his butterfly collection, Native American artifacts, and relics from the tragic Donner Party. Admission to the museum was free on Saturdays. Eight years later, he built his two-story residence next-door.

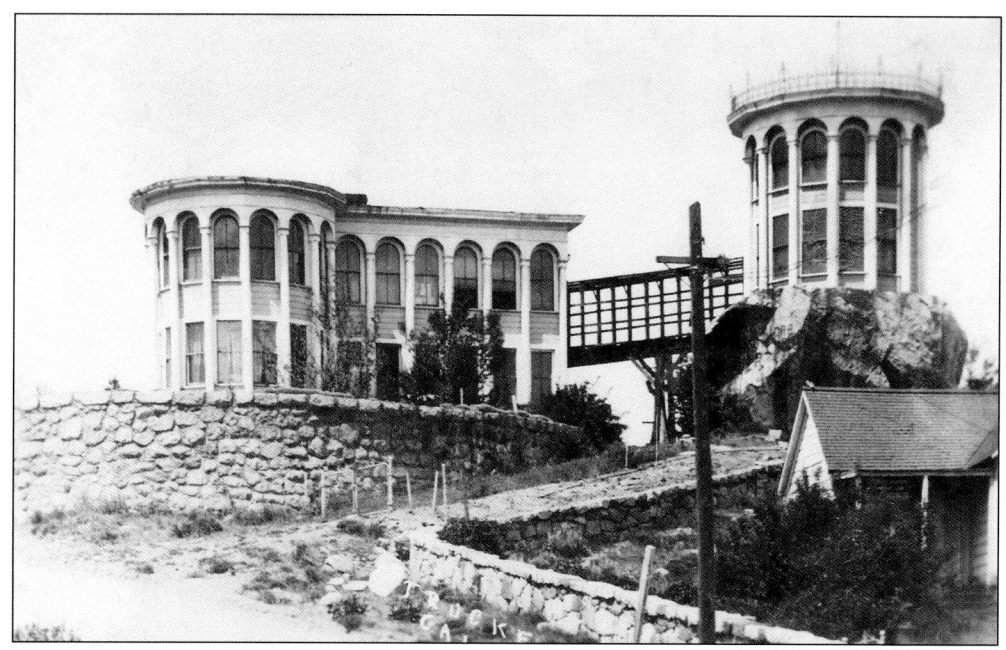

Charles McGlashan's residence was often referred to as "McGlashan's crystal palace." The mansion got its name because it looked like sparkling crystal when the museum and home were lit up at night. Mimicking the museum's design, McGlashan installed windows all along the front of the home to capture the view. The home was destroyed by fire in 1935.

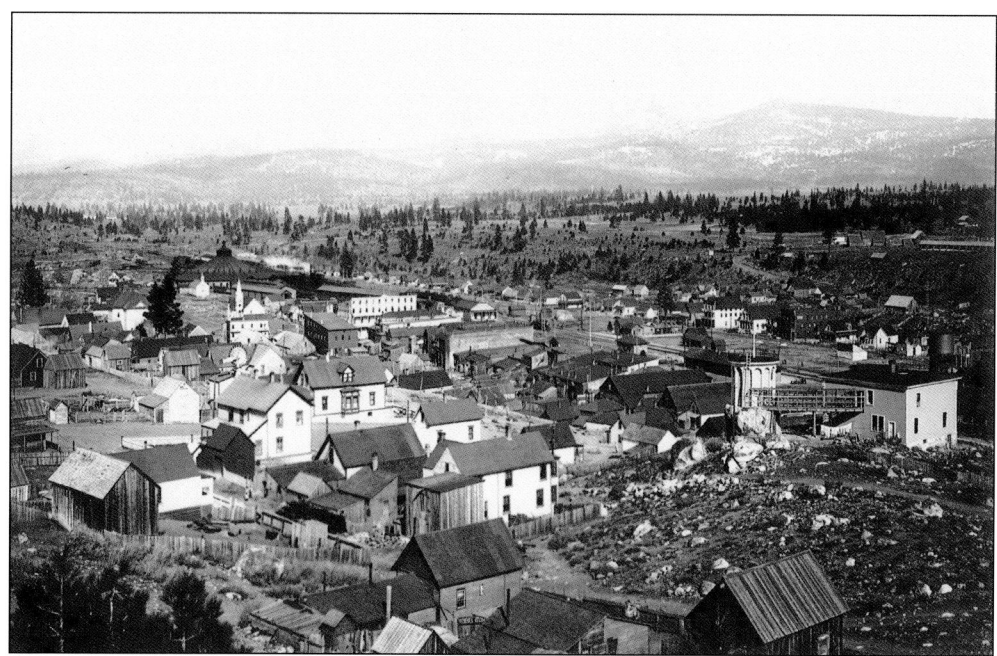

The view from above the Rocking Stone Museum shows how Truckee was growing just prior to 1890. The new granite railroad roundhouse, started in 1882, is visible in the distance, as is the Assumption Catholic Church that burned 1890. Showing prominently is the white, three-story Whitney Hotel on Bridge Street.

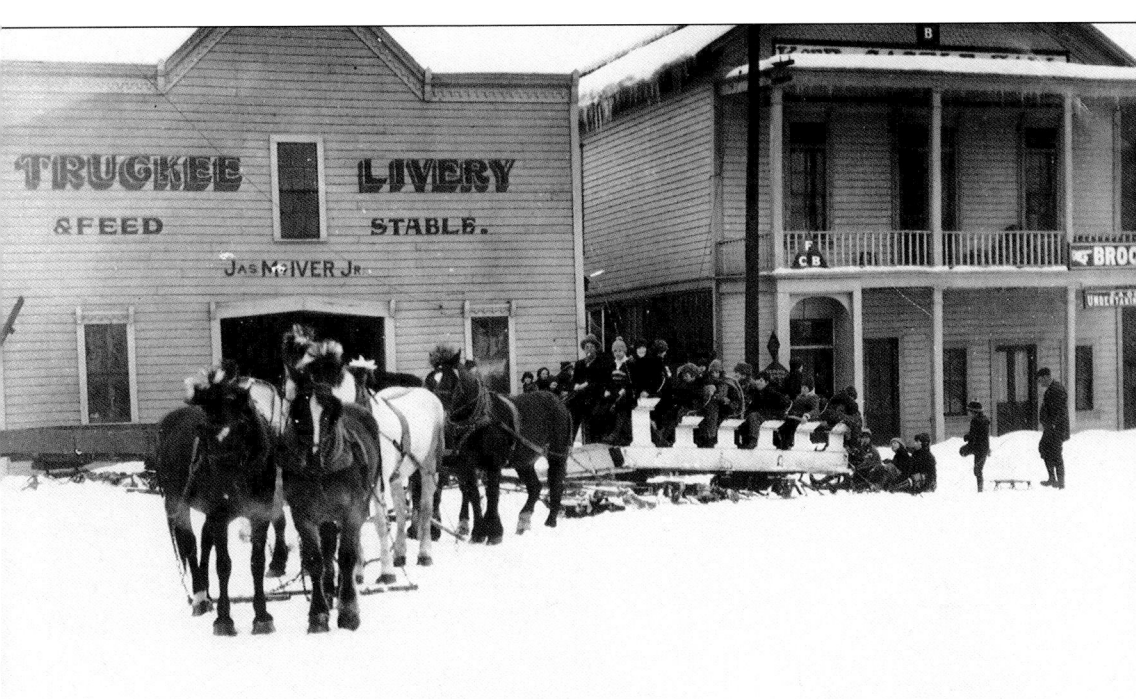

The Truckee Livery Stable and Feed was owned by James McIver, whose family also owned a dairy slightly west of downtown Truckee. Born just east of Truckee in Floriston, McIver lived in Truckee for many years. He was also a blacksmith, teamster, and the owner of McIver Garage. He served as a sergeant during World War I.

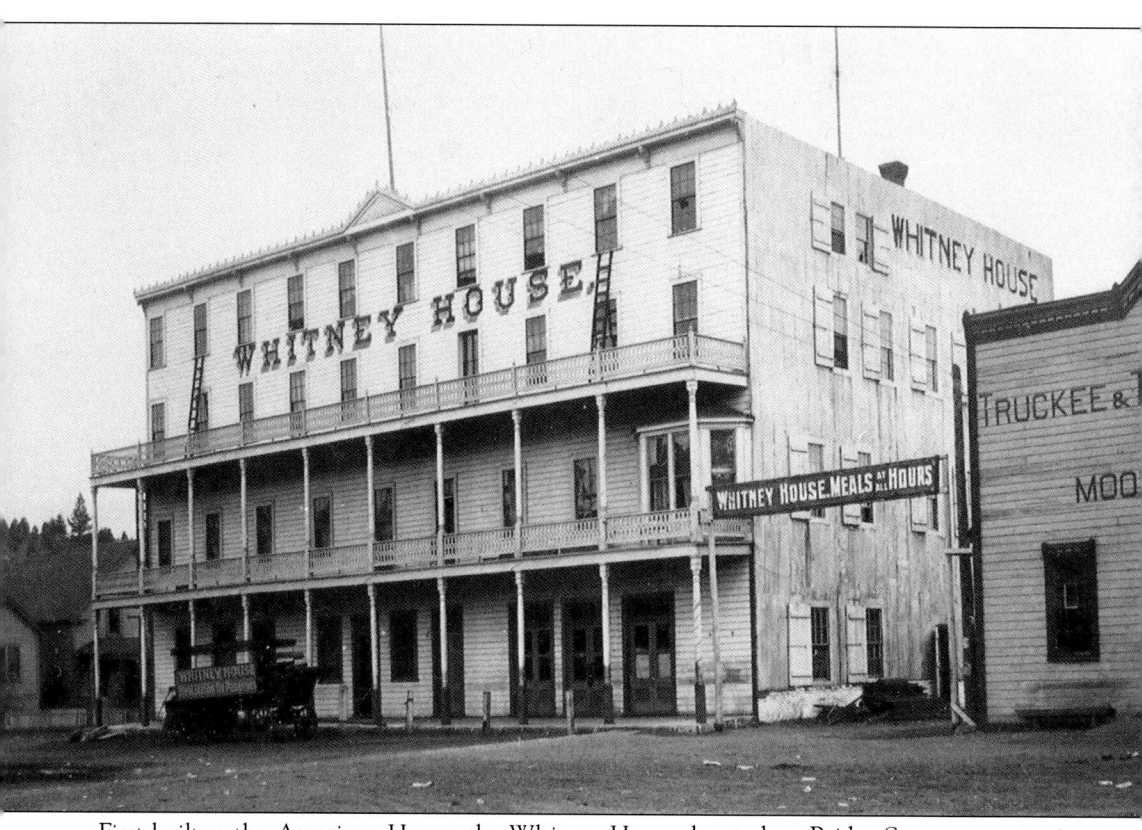

First built as the American House, the Whitney House, located on Bridge Street, was a major stagecoach stop along the Dutch Flat–Donner Lake Wagon Road. The name changed from American House after a fire, and it would change many more times after fires and with subsequent owners. Today, the property is named the Truckee Hotel and sits on the historic registry.

Charles Adam Ocker came to America at the age of 13 and moved to Truckee in 1881. He learned the undertaking business in San Francisco after years of working for Truckee Box Company and in Boca as a wood contractor. After returning from San Francisco, he bought Truckee's funeral home from William McDougald. Ocker later became the town's justice of the peace.

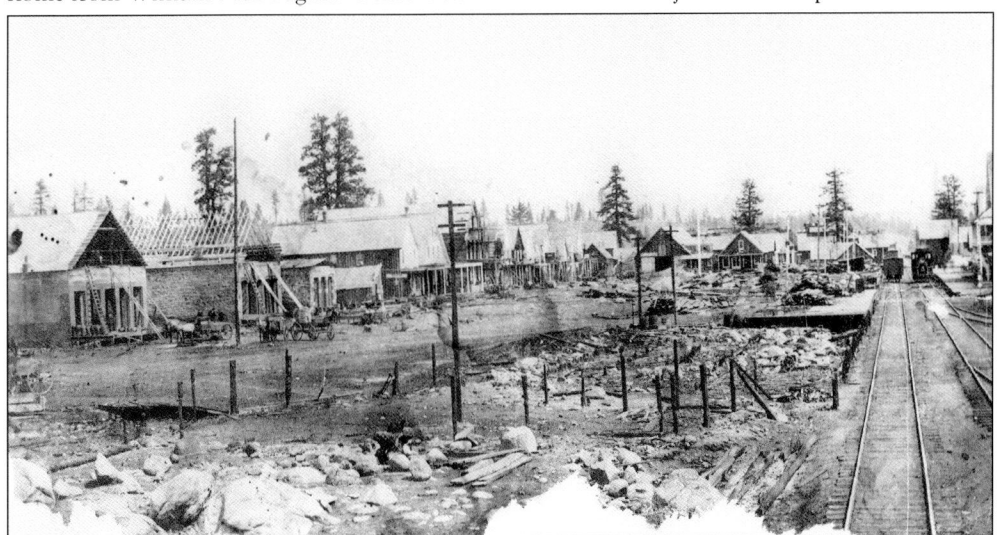

Fire was a common occurrence in the early days of Truckee's history. This fire in 1868 destroyed the train station and the American House, as well as other structures. The Truckee Hotel (partially pictured on the right side of this photograph) appears to have been spared, judging by the condition of its balconies. The fire happened just months after the first train rolled through town and the town's name was changed from Colburn's Station to Truckee.

The C.B. White House was originally built by William Henry Kruger, who was a partner in Truckee Lumber Company. Charles Bernard White arrived in Truckee in 1896 as an employee of the Southern Pacific Railroad Company. Throughout his years in Truckee, he was an agent for the railroad, a banker, and an all-around businessman. His family moved into this home in Brickelltown in 1904.

Truckee had a small hospital, located in its Brickelltown neighborhood. The flu epidemic in 1918 hit Truckee hard. Doctors scrambled to keep up with the outbreak. Some say the Spanish Flu killed more residents of Truckee than any other single event. Truckee suffered one of its worst winters in 1919, which certainly did not help with fighting this great plague.

Originally from Maine, Warren Richardson headed west in search of gold, arriving on the West Coast with his brother George in 1851. After mining in Downieville and lumbering in Colfax, they moved to Truckee. They started Richardson Brothers, a successful box factory in Martis Valley, and Warren became one of the wealthiest men in Truckee. He built this home for his family in the 1880s.

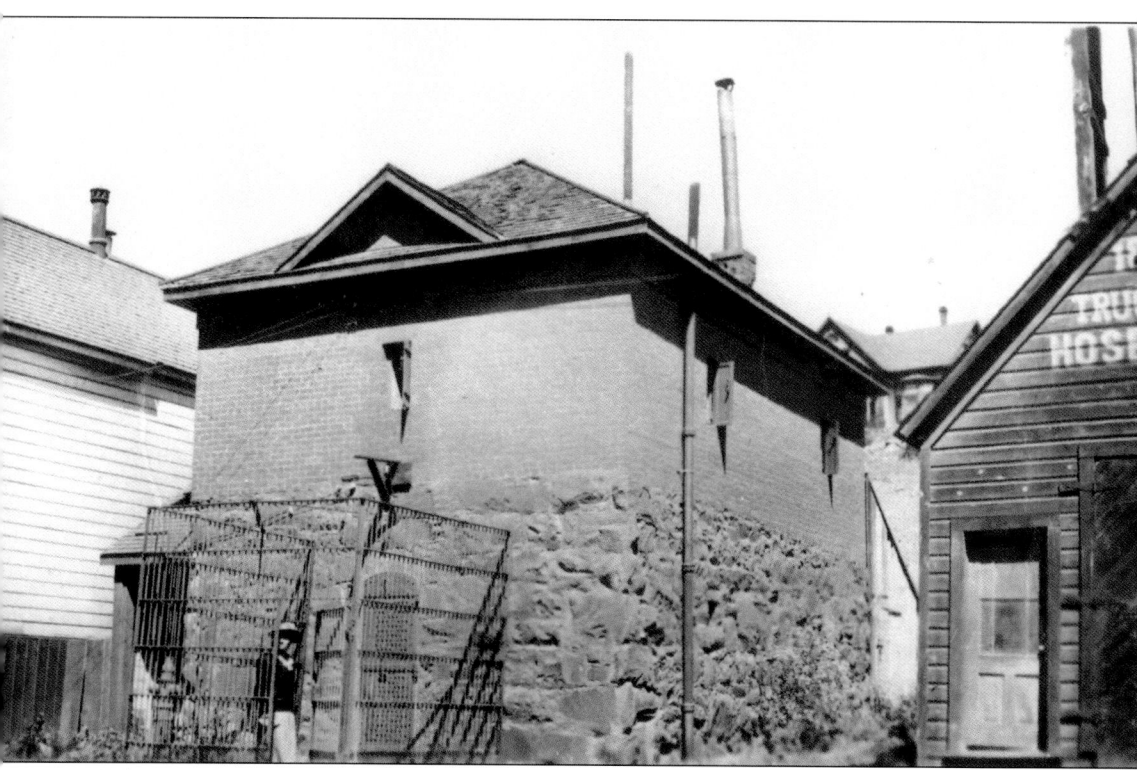

When Truckee lawmen realized that housing prisoners in a Brickelltown building wasn't adequate, townspeople donated $25 each to build the jail on Jibboom Street in 1875. Originally built using native stone and with only one story, the second story was added in 1901 as a hospital ward and holding place for female prisoners. The jail still exists today as a museum for the Tahoe Donner Historical Society.

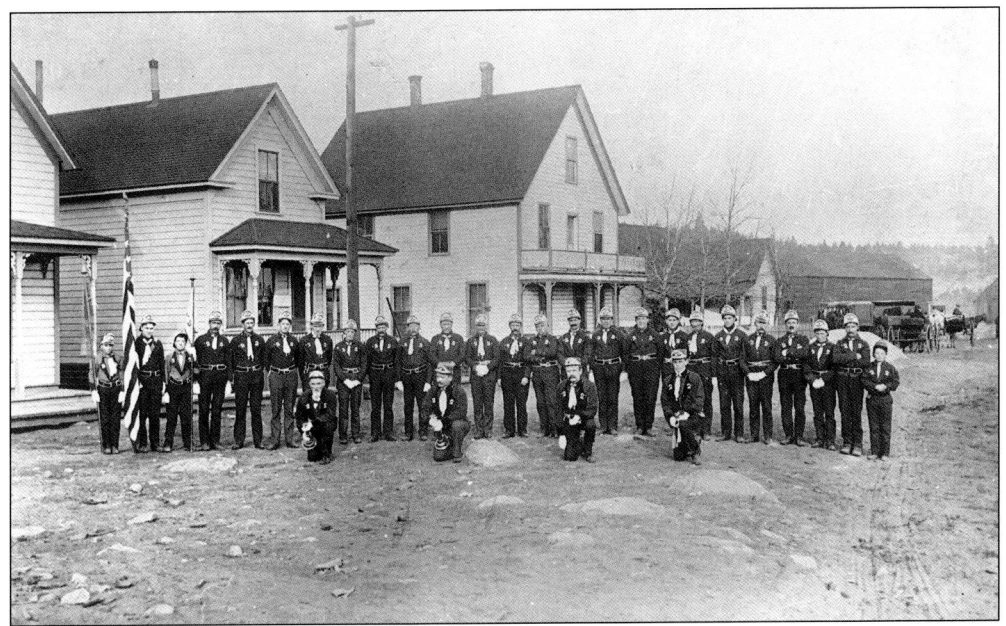

By the time this photograph was taken in 1894, Truckee had already seen its share of devastating fires. The original firehouse was next to the jail on Jibboom Street. It boasted five hose carts and about 200 feet of hose. Most fires in Truckee were started at night by embers that escaped from fireboxes. The Truckee Fire Protection District was created in 1894.

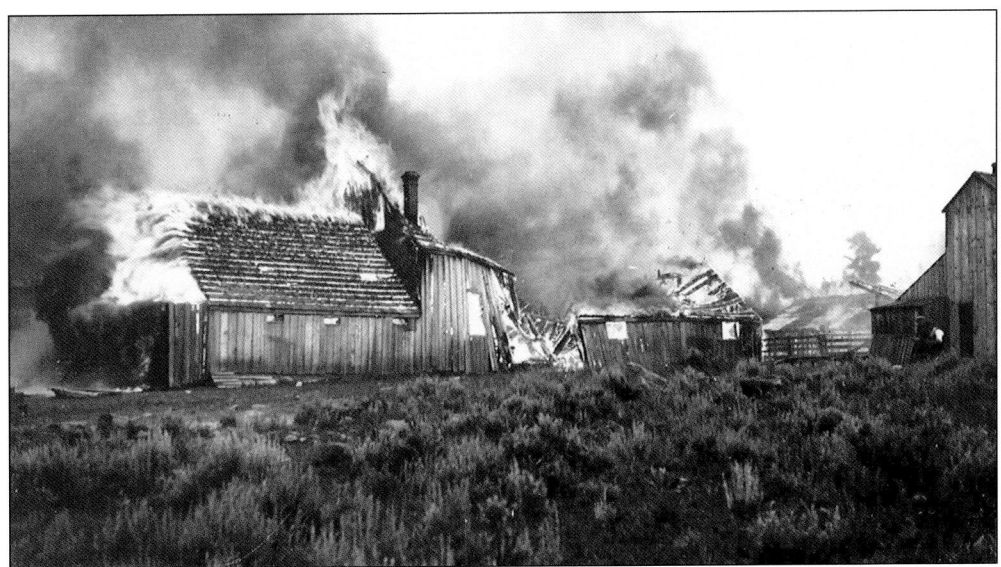

The Russi Slaughterhouse, located at Hilltop above Truckee, burned in the 1920s when the town was still using 19th-century equipment to fight fires. When a structure caught fire, one could only yell, "Fire! Fire!" and then run to the fire station to ring the fire bell. With all that time lost, not many structures were saved.

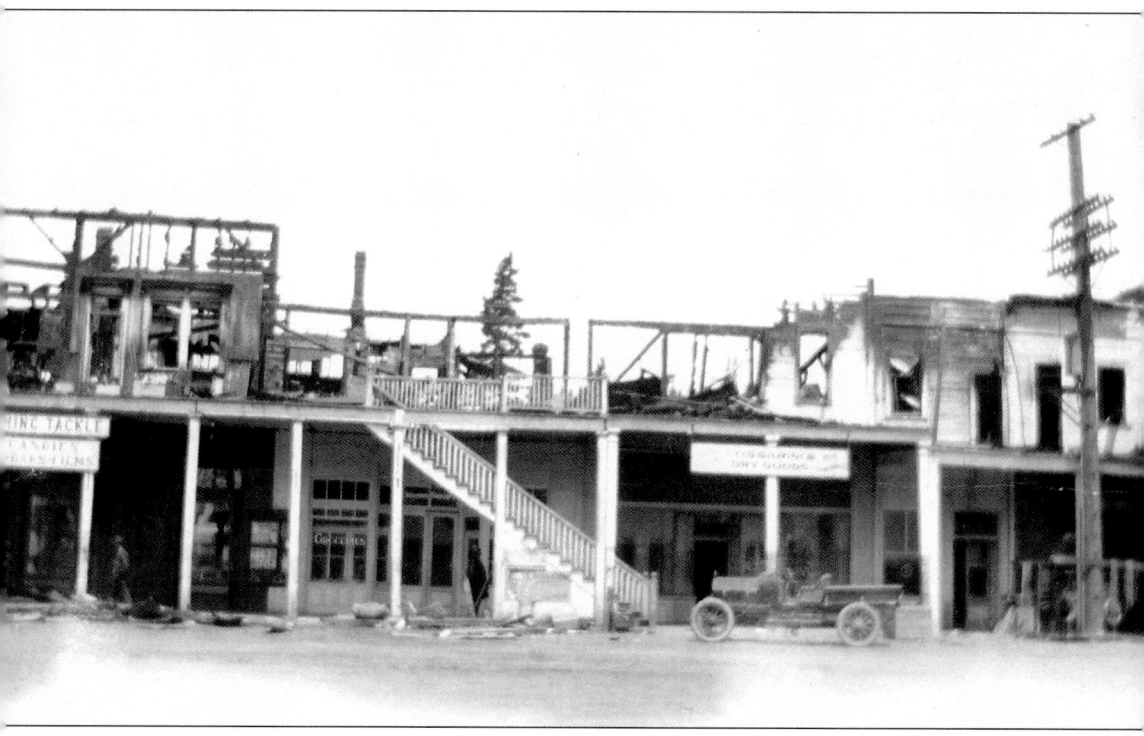

In 1922, a large portion of Front Street was yet again burned. At this point, a telephone system for reporting fires was in place downtown and on Hilltop. Still, this fire did its damage, even though the firehouse was just behind these businesses.

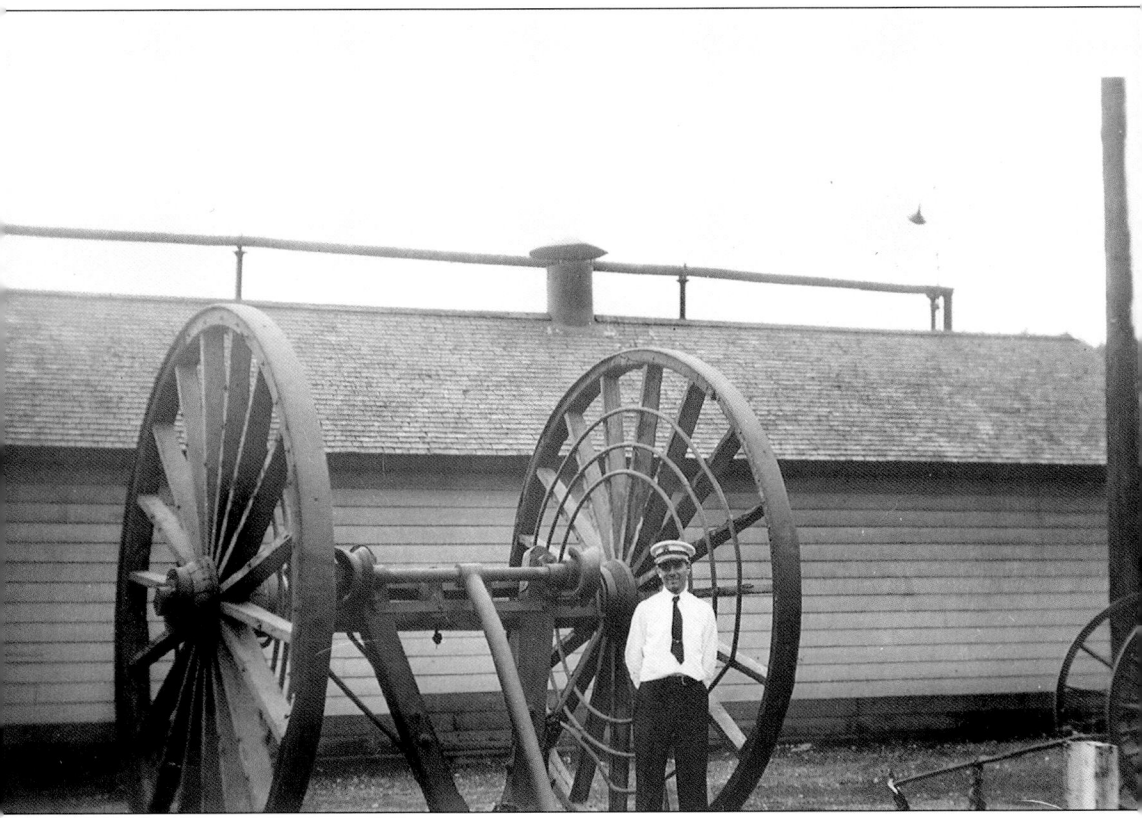
Tony Pace volunteered for the fire district for 30 years and for 16 of them was an assistant fire chief. He stands in front of the large wheels that were next to the Southern Pacific Hotel. In 1937, the district purchased its first new fire truck and hired a driver to man it 24 hours a day.

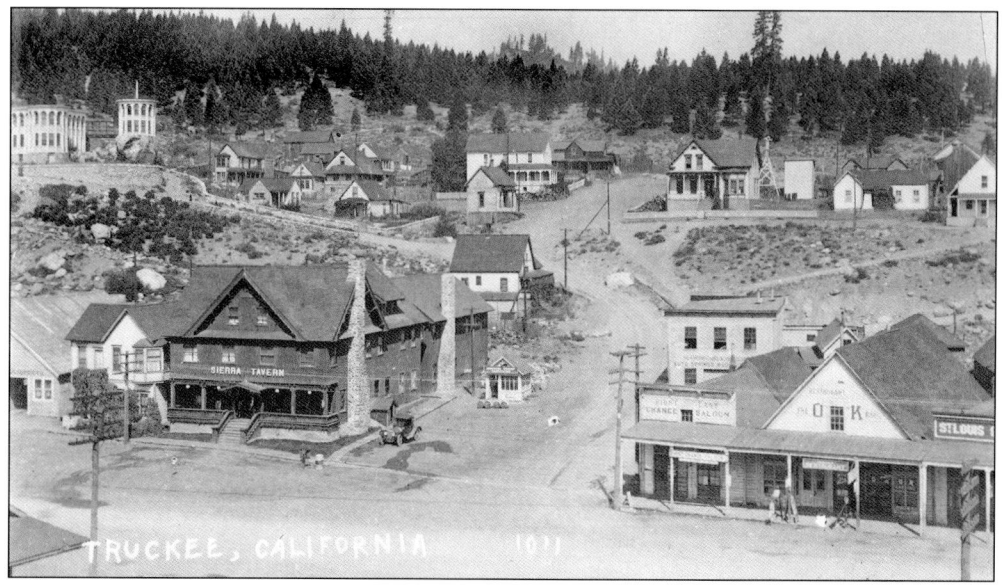

This view of Spring Street shows Sierra Tavern in the foreground to the left and the McGlashan mansion at the top of the hill on High Street. Sierra Tavern burned in 1927 and was rebuilt in 1928 by its owner, Tim O'Hanrahan, just east of its original location. It began as a three-story building and a fourth floor was added in 1937.

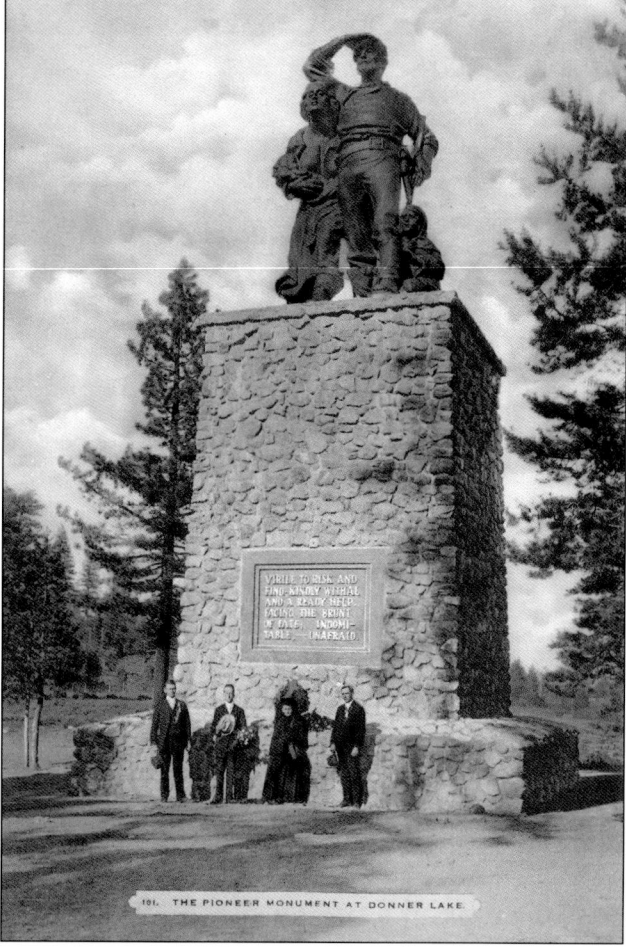

The Pioneer Monument at Donner Lake was built to honor the ill-fated Donner Party that turned to cannibalism as a means of survival during the winter of 1846–1847. The monument's base of 22 feet signifies the amount of snow that was on the ground that winter. Built in 1895, the monument cost $2,500.

Two
GETTING BUSINESS DONE

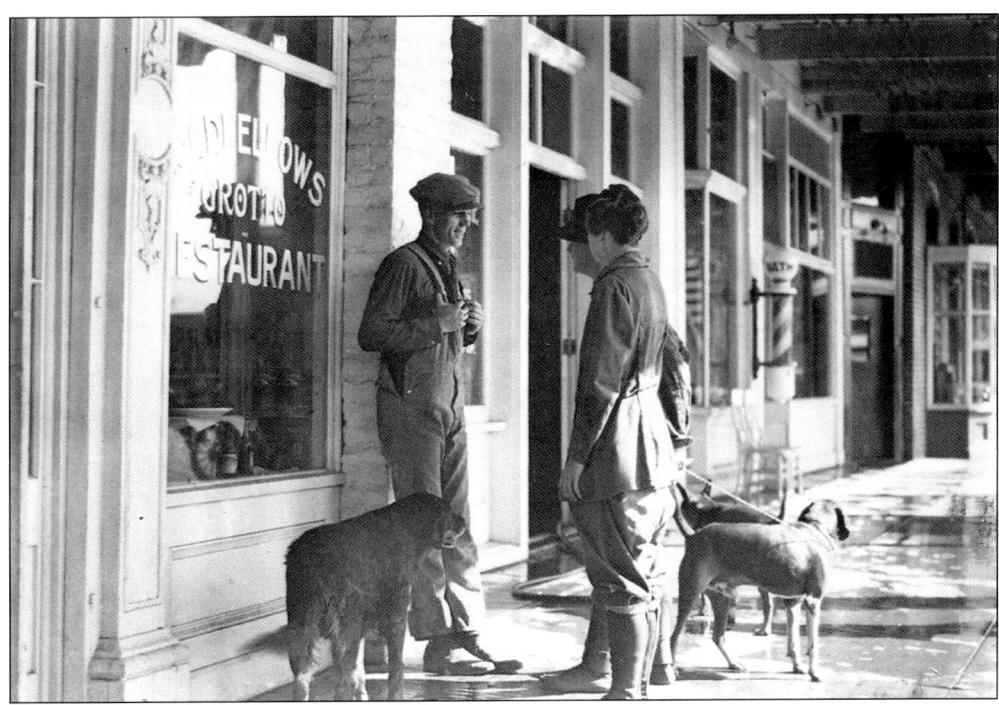

Truckee's downtown core bustled with action both day and night. Here, a couple talks with a friend outside of Goodfellows Grotto Restaurant. Between 1885 and 1898, it was a dry goods and clothing store owned by W.M. Burckhalter; he would sell it to H.W. Wilmouth and F.M. Rutherford. At one point, it was a pool hall. Today, Goodfellows is home to Coffee And, a popular eatery.

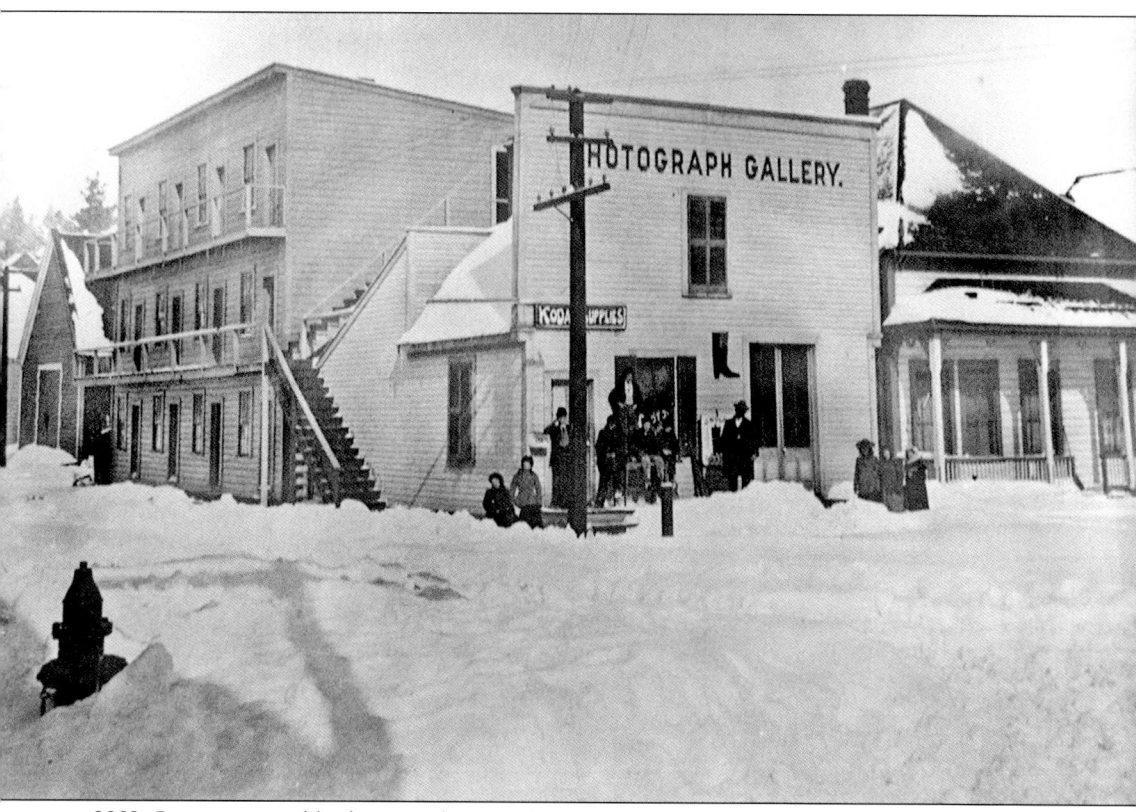

H.K. Gage was possibly the most famous photographer to come out of Truckee in the 1800s. He is known not only for his portrait photography, but also for capturing Truckee's history on film. Born in Massachusetts, Gage set up shop at Church and Bridge Streets in Truckee between 1874 and 1886.

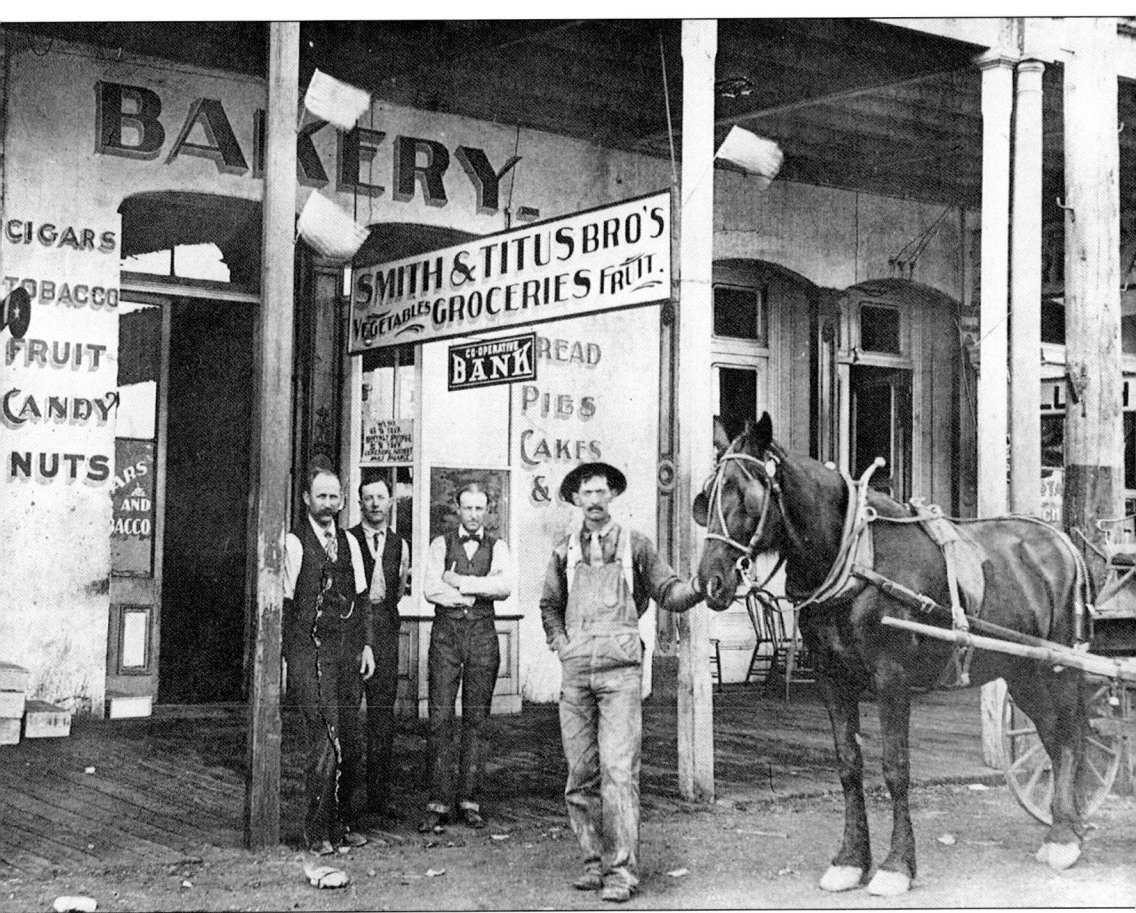

It was not unusual for a storefront to have many uses. The Smith & Titus Bakery also served as a bank, and it sold everything from cigars to nuts. Both the Smith and Titus families were prominent in Truckee. Charles Smith ran mail and became a justice of the peace in the 1930s, while Frank Titus worked as a surveyor and engineer on the narrow gauge between Truckee and Tahoe City. He later worked as a night policeman and deputy constable.

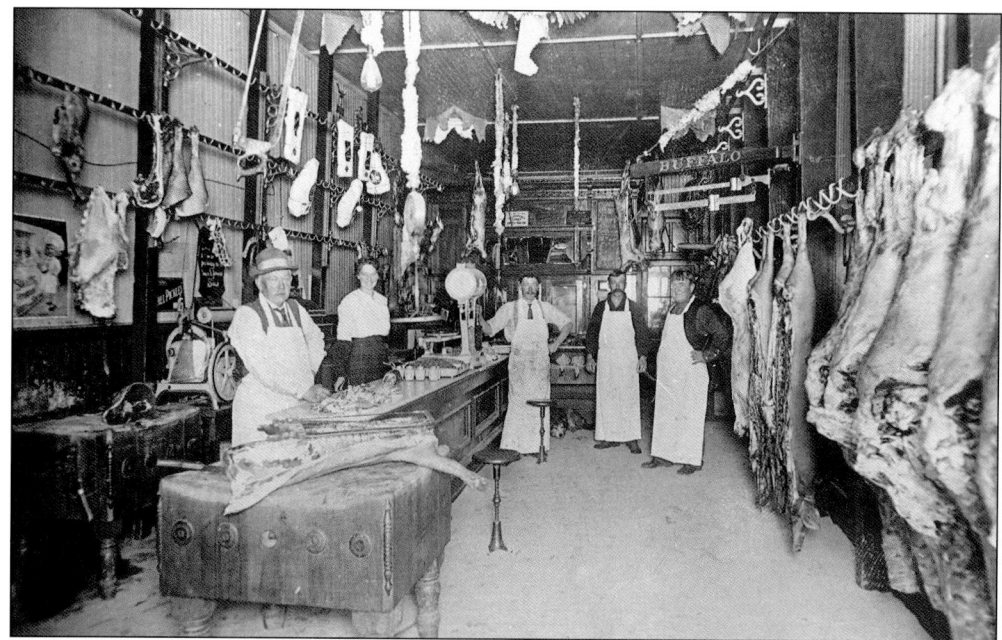

In 1913, Charlie Siegel, along with Ed Owens, operated one of the town's two butcher shops. In this photograph, Siegel is on the left and Owens is on the right. They owned a slaughterhouse on Hilltop, just above downtown. The butcher shop, located on the west end of Commercial Row, burned to the ground.

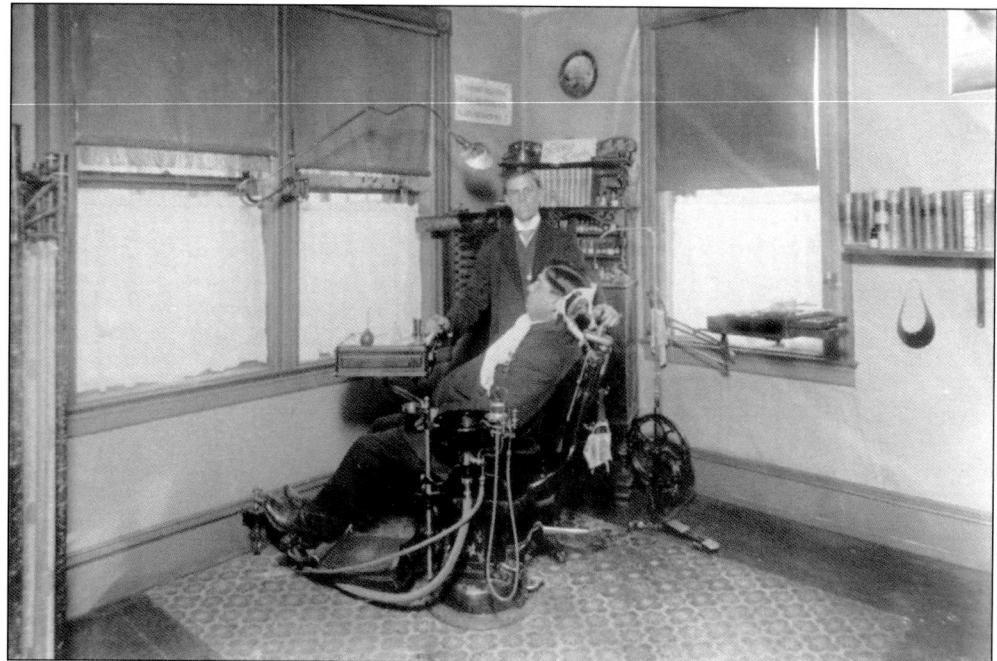

Dr. George Kelly, DDS, had a second-story office on Main Street. It was above a brick building that housed several businesses, including a variety story, soda fountain, saloon, grocery store, and post office. The wooden second story burned in one of Truckee's infamous fires, while the bottom floor was saved.

The Volstead Act, signed into law January 16, 1920, prohibited the selling and consumption of alcoholic beverages. During this time, illegal distilleries in Truckee popped up on every corner. It was said that the sewers clogged from the amount of corn mash being dumped in the gutters. With the poor economy, home distilleries were some families' only form of income.

It was rumored that Baby Face Nelson lived in the Sierra Tavern during Prohibition. Truckee was known for its whiskey and gin, and after the Volstead Act was signed into law, Truckee's saloons became "soda fountains." It was a known fact that Truckee was distributing alcohol to buyers in San Francisco and Sacramento, but local lawmen overlooked it because of the mob-like atmosphere in town. The practice continued until Prohibition was repealed on December 5, 1933, giving state governments control over the production and distribution of alcohol.

McIver's dairy farm was a thriving operation that supplied the region with butter and milk at the turn of the 20th century. In all, there were about 15 to 20 dairy farms in the Truckee and Martis Valley areas. It is said that up to 60,000 pounds of premium butter were produced each year. Not only was butter used for cooking, it was used to grease the area's logging skids, as well.

W.F. Wilkie opened Truckee Mercantile Company in 1893 after working at Truckee Lumber Company's general store. When the store was closed, he opened the Mercantile Company. He was a charter member of the Truckee Chamber of Commerce and sat on the board of school trustees. Tom Dolley, a man well entrenched in town activities, later owned a portion of the Truckee Mercantile Company.

The New Whitney House was built after the American House and original Whitney House burned. Later iterations were the Blume Hotel, Riverside Hotel, Alpine Riverside Hotel, and, finally, the Truckee Hotel. This Bridge Street photograph includes a portion of H.K. Gage's photography studio, as well as the auto yard. Later, Stone's Garage would open directly across the street.

The largest rainbow trout pulled out of the Truckee River, displayed here, weighed eight pounds. Above the fish is a box for Dim-A-Lite bulbs, possibly the first patented light bulbs that could be dimmed. The lights were invented in the 1890s and were seen as a way to lower power consumption.

Frank "Waddles" Maher was the longest acting fire lookout on Martis Peak, which offered perfect views of the Tahoe Basin and Sierra Valley. Manning the Martis Peak Lookout from 1917 through 1943, Maher named the lookout "Hotel de Chipmunk," after the dozens of chipmunks that called the peak home. He named the chipmunks after famous people who visited the cabin, such as Frank Sinatra, Jack Dempsey, and Theodore Roosevelt.

P. Franzini was one of the many Italians that moved to Truckee, and specifically into Chinatown, once the Chinese were driven from River Street. During Prohibition, it was said that the Italians were allowed to make their own wine down on River Street. Franzini's operated as the other "soda fountains" in town did.

Mary Lewis bought a failing candy store shortly after her husband, Joe Lewis Sr., died in 1903. She expanded the business in 1907 when others were having a tough go in the difficult economic times. She added a post-office contract and sold new Kodak cameras. Over time, the candy shop became a true general store. By 1910, hers was one of the most successful businesses in Truckee.

Joe Lewis Jr. helped his mom, Mary Lewis, at the general store when he wasn't shooting photography. In 1913, Mary sold the business to her son. The store continued to be successful. When Joe died in 1928, his widow, Hazel, continued running the store.

Originally known as the Louver Bar, the Pastime Club was established in 1890 by "Big Four" heavy-hitter Charles Crocker. Crocker sold it to a man named Abner Weed, who eventually founded the town of Weed in Northern California. In 1925, Weed sold the bar to Dick Joseph, who owned the Bucket of Blood Saloon situated behind the Pastime. It was one of two bars that remained open during Prohibition. When the authorities came into town, the bar was locked front and back with iron doors.

Armenian-born Dick Joseph made quite an impact on Truckee. Born in 1890, he arrived in Truckee in 1917. He bought land from Union Ice Company in the Gateway area and opened a motel and developed a shopping center. He later donated land for the Tahoe Forest Hospital.

Stone's Garage was built in 1907 on the land where Joseph Gray had built his cabin. The garage operated as a blacksmith and carriage house and later serviced cars in this Bridge Street location (across from the New Whitney Hotel). The lot out back was at one time a corral for the carriage business. Unlike downtown businesses built of wood, the garage's stone construction kept the building immune from fire damage. A service station built of wood would have been very vulnerable during this period of town-wide fires. Tom Dolley operated an ambulance service out of the building in the 1940s. Below, Charles Ocker, the town's funeral director and future constable, is seen to the left.

Snow is a way of life in Truckee. Managing the snow load was not always an easy task, but the covered walkways helped keep businesses open. A few covered sidewalks still exist today. Roads, railroad tracks, barns, and houses all needed to be shoveled out, and without today's snow-removal equipment, it was a challenge.

In 1895, a storm again buried Truckee's business core. Men worked from above and below to help dig out the businesses from the massive snowdrifts. In the distance there is a piece of equipment that might have been McIver's snow machine, a precursor to today's snowmobile.

The Nevada Saloon was one of many saloons and gambling halls in Truckee. Gunfights broke out almost nightly, and people were hauled off to jail regularly. A major snowstorm didn't stop the Nevada Saloon from opening. Here the proprietors and friends make good sport of the recent snowfall.

Bridge and Jibboom Streets are buried under snow. In view is the Methodist church, the hotel, Stone's Garage, and a roofless roundhouse. The smoke in the photograph is actually steam coming from the railroad engines. Although managing the amount of snow left on the street in Truckee is different these days, there are mornings that look much like this.

In 1911, mountains of snow block views of the street from Truckee's sidewalks. This was a typical winter scene, unlike the winter of 1846–1847, the winter the Donner Party was stranded in 22 feet of snow at Donner Lake. Another harsh winter came in 1865, when snow made it impossible to work on the transcontinental railroad and Charles Crocker employed Chinese laborers to meet the 1868 deadline.

In 1934, snowplowing had become a little easier because of the invention of the truck snowplow in the 1920s. Prior to that, wooden, horse-drawn plows helped keep the roads clear. Here, the depth of the snow can be estimated by the people visible beyond the snow piles under the covered sidewalk.

Henry Loehr, owner of H.G. Loehr & RASCO Hardware, is seen at the Truckee lumberyards in the 1930s. In 1931, there was a winter storm that swept through for five consecutive days in November, dropping 54 inches of snow. That winter saw a particularly large amount of snowfall. In total, 600 inches fell before summer arrived.

Three
CONNECTING COASTS VIA RAIL

Truckee wouldn't be on the map without the building of the transcontinental railroad and the commitment by Central Pacific Railroad's Theodore Judah to get the route up and over Donner Pass. Built with Rocklin granite, the 22-stall roundhouse in which this engine sits was a testament to the grandeur of Truckee's railroad history. Built in 1882, this roundhouse was in operation until 1939.

Old No. 4 was the first locomotive to be transported over Donner Pass via the Dutch Flat–Donner Lake Wagon Road. It was built in 1865 and purchased by George Schaffer to move railroad ties and supplies to the railroad and lumber to places like Reno and Virginia City. The locomotive was eventually sent to be refurbished and was displayed at the Panama-Pacific International Exposition, the world's fair held in San Francisco in 1915.

Chinese labor was key to the completion of the transcontinental railroad. Here, one Chinese worker carries tea to his fellow workers.

The Chinese cooked for themselves and for others. The 1870 census showed that approximately 1,400 Chinese lived in Truckee. Of those, 34 were women. Of the 34 women, 22 were prostitutes. With the economic depression in 1870, cheap Chinese labor was not appreciated by most of the white residents. Animosity against the Chinese was not helped by the lack of Chinese assimilation.

Chinese workers came to Truckee in droves, set up their own Chinatown, and worked in the service industry, the logging camps, and also for the railroad. The laborers shown here worked at Hobart Mills, one place that openly hired Chinese during a time when businesses were being boycotted for doing so.

The Whitney House hired Chinese waiters in their 24-hour restaurant, which boasted the best meals in town. After the Chinese were driven to River Street, they settled the second-largest Chinatown on the West Coast.

The Irish workers despised menial labor on the railroads, so tough jobs, like hand-digging railroad tunnels, were given to the Chinese. They hand dug tunnels until nitroglycerin was invented, at which point the Chinese were lowered in baskets to set charges in the granite. While white workers were paid $40 per month with room and board, the Chinese workers were paid $30 per month without room and board.

Scores of Chinese workers were brought in to ensure the railroad's timely completion. Although hired to help with the deadline, in the end, the Chinese laid all but 35 miles of track between Sacramento and Promontory Point in Utah. Here, the Chinese are helping to construct one of the many snow sheds meant to shield the tracks along Donner Summit.

A section crew mans one of the snow sheds along Donner Summit. There was a total of 37 miles of snow sheds over the summit to protect the tracks from the drifts that could sometimes top 40 feet. The snow sheds led to the descriptions of this length of track as "the railroad in a barn."

A cab-forward Mallet locomotive makes its way through a snow shed on Donner Summit. Providing better visibility, these Baldwin-built locomotives were used mainly by the Southern Pacific Railroad in the Sierra. They burned oil instead of wood and used their steam twice in the powering process. The first Mallet was delivered to Southern Pacific in 1910.

Affectionately referred to as a "hog," this locomotive makes its way into a summit tunnel. Over the years, the tunnels were modified to help vent the exhaust from the engines. Another technological advance was the invention of the cab-forward locomotive that helped keep the engineer ahead of the exhaust venting from the hot engines.

Truckee's roundhouses were necessary to the operation of the Central Pacific Railroad over Donner Summit because a place was needed to house enough engines to power freight and plows up the grade. After Truckee's first roundhouse burned, the second of three roundhouses, pictured here, was built in 1869. Able to house up to 16 engines, this roundhouse was also built of wood and ultimately burned in 1882.

This image shows Union Pacific and Central Pacific joining rails as the transcontinental railroad reached completion May 10, 1869, at Promontory Point in Utah. The Central Pacific Railroad's wood-burning engine "Jupiter" is on the left, and the coal-burning Union Pacific No. 119 is on the right. Approximately 500 people attended the ceremony. Several Chinese laborers can be seen in the photograph.

In 1885, the Central Pacific Railroad ceased operations and the Southern Pacific took over. Shown is the first Southern Pacific crew at the repair shop in 1885. Truckee was an important dispatch location for more than 300 miles of track. Train crews switched in Truckee, the first stop east of Sacramento.

The transcontinental opened Truckee to exports and imports. The Central Pacific Freight Depot in downtown Truckee was built in 1891 and stayed in operation through the 1960s. It once was the location for Curran Ice Storage and Beverage and was remodeled in the 1970s to accommodate retail stores.

The repair shop at the Truckee yards was important to the entire Central Pacific operation with more than 40 engines moving in and out of the yard each day. These crews maintained and repaired many locomotives and could machine parts as needed. Trains derailed often and wrecks were common in those days.

The Bucker plow, used to remove snow from the tracks, was replaced when the rotary plow was invented, making clearing the tracks much easier. The Bucker, or wedge, used up to nine engines to push it through the snow. It was effective, but it was not easy to clear almost 40 miles of uncovered track with it. The rotary plow, invented in the 1884 and put to use over Donner Summit in 1890, could throw snow 300 feet off the track.

This Union Pacific snowplow is shown in 1938 roaring through Truckee. Union Pacific still uses rotary snowplows on the tracks to this day, though they have been converted from steam power to diesel power. In addition to rotary plows, the railroad uses other equipment, such as flangers and spreaders, to help keep up with the falling snow.

Before plows were available to clear the tracks, all snow had to be removed manually. Even when snow fell in amounts up to 12 feet, it had to be cleared to lessen delays along the line. Sometimes up to 100 men would be needed to shovel the snow off the rails between Truckee and Colfax.

Cashing in on Truckee popularity as a destination along the railroad route, the Central Pacific built its own hotel downtown. It operated both as a hotel and as the trainmaster's office, where much of the logistics for the Truckee rails and rail yard were managed.

As more than 40 engines made their way through the yard and scores of people and freight were being moved east and west, the trainmaster's office was a busy place. Truckee was deemed a "helper" district, which meant that it could provide extra power to get more than 100 cars up and over the summit each day. The trainmasters had their hands full managing freight and excursion train schedules.

The granite roundhouse was the third and final roundhouse in Truckee's railroad history. To make sure this roundhouse did not meet the same fiery fate as the other two roundhouses, this behemoth was built using Rocklin granite and a metal roof. Built in 1882, this roundhouse had 22 stalls and was one of three completely circular roundhouses on the Southern Pacific line. The others were in Texas and Louisiana.

The crew at the roundhouse was kept busy. As the Mallet trains came on line with their longer length, the roundhouse and its 62-foot diameter turntable were unable to move the massive locomotives. By 1911, Southern Pacific had built a balloon track in the rail yard so that the Mallets would have enough room to turn around.

Excursion trains became popular as soon as the railroad opened its route over the summit. Not only did they transport people to and from Truckee, they also made stops along the route, as seen here in the American River Gorge just west of Donner Summit. The train secured Truckee's existence as a destination.

Fire trains were a necessity on the railroad, as trestles and tunnels caught fire with embers escaped from fireboxes. The Samson was Truckee's first fire train. Not only did it respond to emergencies along the railroad, but it also provided protection for the second roundhouse and to businesses along the rails in town.

The tracks between Truckee and Reno were doubled by 1915, which helped with the response of the fire trains stationed in Truckee. No longer would the fire trains have to wait for the lines to be cleared. With better snow removal equipment, some snow sheds were not replaced after being damaged. This led to a decreased need for the fire trains, which were eventually moved to Andover in 1923.

Trains going over the summit often had a difficult time of it in the early years. Derailments, fires, and accidents happened often, keeping Truckee's wrecking train in demand. Taken in 1882, this photograph shows the Central Pacific wrecker sitting on the tracks west of the rail yards in downtown Truckee.

Apparently, the Pacific Limited locomotive had its share of bad luck. This image is identified as being the wreck of the Pacific Limited in 1936 when a snow slide derailed the train. In 1944 in Utah, the Pacific Limited was involved in a collision with another train, and 48 people were killed.

A cab forward train is pictured leaving Truckee and heading west through Brickelltown. McGlashan's mansion can be seen on the hill to the right, while the New Whitney Hotel can be seen in the distance, to the left. A small, narrow-gauge rail line, probably built for the mills, runs parallel to the Southern Pacific rails. Double tracking on the rails dates this photograph to the 1920s.

Train passengers seek out their trains. These Pullman sleeper cars were made of metal, unlike the first wooden Pullman cars that rolled through Truckee. The transcontinental railroad made interstate travel comfortable in these "hotel" cars. In the distance, there is a throng of people waiting to board the train.

The train called the *City of San Francisco* is best known for being stranded on Donner Summit in the winter of 1952. When a blizzard rolled into the Sierra, it left the streamliner buried in snow for six days in mid-January. Even snowplows froze to the tracks during this storm, leaving the workers and volunteers nothing but their own strength with which to rescue the stranded passengers.

Four

LOGGING THE SIERRA HILLS

The Truckee area was rich in logging operations, providing lumber for the transcontinental railroad, development of surrounding cities, the paper mill in Floriston, and supports for Nevada's Comstock mines. Hobart Mills was probably the best known of all the logging operations. It had its own community, narrow-gauge railroad, and hotel north of Truckee. Here, the head saw makes the first cut.

Providing materials for the Comstock Mine, Sierra Nevada Wood and Lumber Company began operations in 1862 in Incline Village, Nevada, on the north shore of Lake Tahoe, before moving to its ultimate location north of Truckee. The company needed access to forests as well as room to expand. Walter Hobart moved his company to the new location in 1898 and named the new town Overton.

Overton, named in honor of Capt. James B. Overton, was already the name of another California town, so in 1900, one year after the mill began operating, the name was changed to Hobart Mills. Prior to the extensive railway system, cordwood was transported via horse wagon. Land purchased for Overton contained 70,000 acres of virgin timberlands.

Needing a way to load logs onto railcars once the narrow-gauge railroads were put in place, McGiffert Loaders were invented. Manufactured in Clyde Iron Works of Duluth, Minnesota, the loaders were first used in 1902. The log loader pictured here is part of the Hobart Mills operation. It is thought that the mill's general manager, George D. Oliver, was probably the photographer, as he was known to be an avid photographer.

The atmosphere in Hobart Mills wasn't as tough as it was in Truckee, which was only six miles south of the mill. There wasn't any alcohol permitted in the community, which kept fights and crime to a minimum. A crew from the mill is pictured here with a Chinese chef. When businesses were firing Chinese workers in response to the boycott, Hobart hired even more Chinese for tasks such as cooking and chopping wood.

Hobart Mills went from being a small mill town to a community of more than 1,200 people in the summer and 400 people in the winter. The mill had 500 workers on its payroll, all of whom counted toward Hobart Mills' summer resident tallies. The town boasted running hot and cold water and electricity in all the homes, and there was a one-room schoolhouse that allowed for eight classes to learn together.

Sundays at the log camp were quiet. There was a box factory and another factory that made sashes, doors, moldings, and blinds. This tent may have been part of Ragtown, a small settlement of tents just outside of Hobart Mills. When the mill was running hot, it processed 125,000 feet of lumber in a 10-hour shift. Over the years, 20 million feet of lumber were cut.

Prior to the use of cardboard, wood boxes were used for shipping. California's agriculture industry depended on these boxes for transporting fruits and vegetables nationwide. A typical order for pine boxes could include almost a million orange boxes that would fill 222 railcars. An order like that took about 111 days to fill.

There was a large warehouse at Hobart Mills to support operations. A standard-gauge railroad, the Sierra Nevada Wood and Lumber Railroad brought supplies to and from Truckee and the Southern Pacific Railroad. As the demand for Sierra pine grew around the world, the town flourished.

The Hobart Southern Railroad Company replaced the Sierra Nevada Wood and Lumber Railroad after the company changed its name in 1917. The railroad brought many visitors to Hobart Mills. They stayed in the town's hotel and took tours of the mills, where a catwalk gave them a bird's-eye view of operations. The last log sawed at the mill was on September 25, 1936.

A popular figure in Truckee logging history is George Schaffer, who began Truckee's first lumberyard with Joseph Gray in the 1860s. The pair built a toll bridge across the Truckee River as part of the Dutch Flat–Donner Lake Wagon Road. Shaffer bought out Gray's interest in the lumberyard and opened a mill in Martis Valley. He made his fortune providing wood to the Central Pacific Railroad, the Virginia City mines, and to the cities of San Francisco and Sacramento. To provide lumber to the Central Pacific, he brought the first locomotive over Donner Summit, using oxen to pull the engine along the wagon route.

Lumberman George Schaffer built several homes in the Truckee area, finally settling in Martis Valley. Not only did he run the mill, he also kept a herd of cattle to supply meat and dairy products for the employees who boarded at his home.

William Henry Kruger and E.J. Brickell were partners in the Truckee Lumber Company after Kruger bought out George Geisendorfer's share in 1873. The company was located along the Truckee River just east of downtown. To help move lumber from the lumber company, as well as from Elle Ellen's sawmill nearby, the railroad constructed a side track.

Five
ICE HARVESTING BECOMES A KEY INDUSTRY

Truckee was known for temperatures that could regularly fall to 15 degrees and below. This made Truckee and the surrounding areas perfect for harvesting ice to transport throughout the country. Ice harvesting, combined with refrigerated railcars, provided the means to export California's agricultural products. These icemen worked in the Sierra's coldest temperatures to get the ice cut and out of the ponds.

Trout Creek Ice Company was one of 20 ice-harvesting companies in the Truckee area. Here, the ice has been scored in one direction and is being scored in the opposite direction with the help of a horse-drawn plow. Men are waiting to break off the nearly perfect one-foot-thick blocks.

This photograph, taken at the Boca ice pond, shows the icemen breaking off the rafts of ice that generally measured 22 inches wide by 6 feet long. They used pikes to move the rafts of ice to the chute. There, the ice was cut into more manageable blocks before being moved via ice elevator to the icehouse.

Boca Mill Ice Company began operating in 1878 and Boca, just five miles to the east of Truckee, began to prosper. When the rivalry between competing ice companies in the area became overwhelming, various ice companies combined to form Union Ice Company in 1881. Lloyd Tevis of Wells Fargo Bank was made president and Edward Hopkins, nephew of railroad magnate Mark Hopkins, was named vice president.

The Union Ice Company incorporated in 1891. It provided ice for the many railcars that were traveling nationwide with California produce. Ice needed consistent cold temperatures. If it rained during the freezing process, the damaged ice would be broken up and flushed out to make room for another ice crop.

Ice elevators were key in moving the 300-pound blocks of ice into icehouses or directly into railcars. Once the ice was loaded into the icehouses, it was insulated with sawdust and stored until the summer when the demand for ice increased. The earliest icehouse was built to store up to 10,000 tons of ice, enough to provide California with ice for several years.

This Boca icehouse is flanked by the railroad and the Boca Brewery. Some of the largest icehouses measured between 400 or 500 feet long and 40 feet wide. It was reported that in the winter of 1874–1875, Boca had a successful season with two ice harvests, one 12 inches thick and a second 16 inches thick.

Harvesting the ice at just the right time was important. The coldest, driest month was December. Snowfall would interfere with the harvests, as the ice would need to be plowed. From January through the end of the winter, snow was practically guaranteed. Here, icemen rush to beat the thaw.

85

Although the process for creating artificial ice was invented in 1910, the demand for Sierra ice continued to grow. Other innovations, such as the gas-powered ice saw, helped the Sierra ice harvest by speeding the cutting process. At the height of the ice industry's operations, around 1910, there were approximately 1,500 men working in the area, 1,000 of them working in the Boca ice pond.

The summer ice crew made sure ice was sent out to places near and far. Summer operations included shipping ice at a rate of 400 tons per week to places like San Francisco, Reno, and Virginia City. Not only was ice used to refrigerate perishables, it was also used to cool drinks. Artificial ice was considered inferior, and demand for Sierra ice grew.

The Prosser Creek icehouse was built into the profile of the canyon and was 500 feet long. The surrounding dam had a fish ladder and holding pond for ice in the winter and logs in the summer. The icehouse was built below the dam and ice pond so that gravity could help with the movement of ice into the icehouse.

Iceland, 13 miles east of Truckee and just a hop from Floriston, was the location of the People's Ice Company. The land was leased to the ice company by Joseph Gray, who had part ownership in the company. There were three other ice operations in this area, which ultimately led to the temporary settlement of the location. The settlement's population was large enough to warrant a post office from 1872 to 1891.

The water at Boca was so pure and cold that it inspired the Boca Brewing Company to begin operations there in 1876. With five springs that fed the area and the brewery with mountain freshwater, the beer quickly became a worldwide hit. Latimer Doan founded the company and started with production of 120 barrels per day, requiring 10,000 pounds of barley and 200 pounds of hops.

Both from Baden, Germany, the first master brewer Leonard Freidrichs and superintendent William Hesse oversaw the crew, also mostly from Germany. The entire crew lived in company housing. The 70 to 80 employees were treated fairly and paid well, keeping turnover to a minimum. These railcars were used as branding for this popular beer.

By 1878, the beer was being shipping to many countries oversees, from Europe to Asia and Australia. It made a hit at the 1883 World's Fair in Paris, France, and gained popularity at local watering holes when Truckee's water quality was questioned and residents were afraid to drink it. Boca's water was pure, and its purity could be tasted in the potent brews. In 1880, a Bock Beer was added to the brewing company's menu of beers.

Boca Brewing Company also had bottling plants in San Francisco and Salt Lake City. These were two of the company's lager labels. One label sported the aggressive grizzly bear, or what could be translated as the California black bear, while the other label sought to resonate with women. Touted as a family beer, both healthful and wholesome, the labels reflected the company's attempt to entice a broad drinking public.

Between the sawmills, brewery, ice industry, and outdoor recreation, Boca was a popular place to visit in the summer in the 1800s. In 1904, near the beginning of Boca's downfall, the hotel burned. By 1920, the ice industry dwindled to a standstill. Poorly planned timber harvesting left the sawmills dry, forcing their closures. Boca, as a community, disappeared by 1939.

Six
Floriston's Paper Mill

Halfway between Truckee and Reno, Floriston was booming at the turn of the 20th century. Although its history began in ice production, Floriston became famous for its paper mill, possibly the world's second largest in that period. This bend in the river bloomed overnight with a hillside of mill homes, a hotel, school, general store, a hospital, and wood flumes that fed the hungry mill. The railroad depot saw scores of laborers, as well as those seeking a good fishing hole and game hunting.

The Floriston Pulp & Paper Mill opened May 22, 1900, with seven main buildings, a crib dam, and one-and-a-half miles of nine-foot-diameter wood stave pipe to bring water to the mill for power. Seven turbine wheels were fueled by 100 cords of wood each day. The land purchase included 14,000 acres of timberland. The mill was built in six months, using one-and-a-half million bricks baked on-site and almost three million feet of lumber provided by Sierra Nevada Wood and Lumber Company. The total cost of the structure was $500,000.

Early settlers dry farmed California's valleys, creating acres and acres of citrus groves, orchards, and vineyards and giving birth to the state's citrus industry. Stockholders of Crown Paper Company, along with the National Ice Company (which owned valuable land in Floriston), joined forces and incorporated in March 1899. Company shares, sold exclusively to San Francisco investors, went for $100 each in blocks of 4,000 shares. In just one year, the mill was built.

This Frater Collection postcard shows most of the original 40 mill homes built to house laborers. There was a boarding house built for unmarried workers, while married workers were offered four-room houses at the rate of $12 per month. Looking west and just around the bend in the tracks was the National Ice Company. The Truckee River roars past the mill in the forefront of this photograph.

The mill produced manila tissue paper and raisin trays for transporting California's precious crops. Together with Sierra ice and the transcontinental railroad, the state's produce made it not only across the country but to foreign countries, as well. At the height of production, there were more than 500 mill workers. Laborers were paid $4.25 per eight-hour shift and machine operators earned $12 per shift.

Paper at the mill was a product of Truckee pine, shipped nearly seven miles along wooden flumes from Big Meadows. As the distance to stands of timber grew and labor thinned, the Floriston Mill built an aerial tramway in 1920 to move wood. Built at an elevation of 7,500 feet, almost 2,500 feet above the railroad, the tramway was moved by gravity. The weight of the wood helped the wood down to the flat cars, while empty buckets were brought back up to the loading terminal.

On one record-breaking day, February 4, 1919, machine No. 1 produced 80,000 pounds gross weight of butcher paper and wrapper in a 24-hour shift, while collectively three machines turned out 95,000 pounds net weight. In 1907, Floriston Pulp & Paper merged with Crown Paper Company and the Zellerbach Corporation, creating Crown Zellerbach Corporation.

The Central Pacific Railroad used mostly a distinct Eastlake Victorian style in designing their depots. In Floriston, the architecture also shows hints of the Queen Anne style in the cornice detailing. Dormers were prevalent in Central Pacific Railroad's depot design. The railcar was built by McKeen Motor Car Company of Omaha, Nebraska. Union Pacific began this design, but it was McKeen that used round windows for strength and internal combustion engines that were intended to power smaller passenger trains more economically.

95

The Floriston Hotel was the second of two hotels in Floriston. The 60-room hotel replaced the Floriston Inn that burned in 1914. The Floriston Hotel met the same fate in 1949. During its heyday, the hotel was surrounded by lawns and gardens and was known for the hearty meals provided to mill hands and hotel guests. It is said that Floriston was named for the flowers that bloomed in the hills. The mill ran until Christmas Eve of 1930, when complaints of downstream pollution forced the mill's closure.

Seven
Always Room to Play

One Truckee visionary, Charles McGlashan, saw the benefit of celebrating the snow that covered the town's hillsides. The "snow cure" was implemented and winter sports became one marketing tool used to bring people to Truckee when the lumber and ice industries began waning. People arrived in Truckee via the railroad by the droves, ensuring Truckee's future sustainability.

McGlashan envisioned a winter-sports destination in Truckee. He experimented with chicken wire and water and first created a giant icicle that he attempted to ship to San Francisco. Although the icicle never made it out of Truckee, his idea came to fruition with the first ice palace.

In 1896, the first ice palace opened in downtown Truckee. The palace was built using 11,000 square feet of chicken wire and measured 700 feet long and 200 feet wide. The chicken wire was watered every day to sustain the shimmering structure. The palace management ordered 100 pairs of skates from Chicago and had sleds manufactured in Truckee.

98

The ice palace was conveniently located adjacent to the Central Pacific Railroad and the Truckee Hotel, which acted as the depot in those days. The palace became the focal point of Truckee life in the winter. Thousands of people came to skate and toboggan in and on the palace.

Enhancing the ice palace experience, thousands of icicles formed on the ceiling of the oval ice skating rink. The light reflected off of them, making the icicles resemble crystals. Lanterns provided the light at night. The 50-foot walls glistened day and night and kept frozen easily in the frigid Truckee temperatures.

Townspeople and visitors alike lined up to skate in the palace, and special trains began running for people wishing to take part in the skating and sledding. The sled run was almost 250 feet long.

The second palace, named Glad U Kum, burned to the ground in 1916. When this palace burned it was decided that another would not be built. By this time, the winter carnival had been in place for seven years, drawing in spectators and competitors from around the region. It was estimated that 10,000 people came to the area annually for the carnival fun that include Nordic skiing, ski jumping, and dog sledding.

To help move people up the toboggan hill at Hilltop, a donkey engine and cable were purchased from a local lumberyard and mill and hauled to the hill to be assembled as a steam-powered ski lift. Here, the donkey engine is being hauled through downtown Truckee on its way to the south side of the Truckee River.

After Glad U Kum burned, the winter carnival went on. The Southern Pacific Railroad, which received a direct benefit from the added winter ridership, funded most of the publicity and ran special Sunday trains to Truckee.

In the 1800s, there were no clothes made especially for skiing. Women had to wear long wool skirts until the 1920s when they began wearing knickers similar to those worn by men. In the 1800s, men wore work clothes and lace-up boots. Skirts made skiing very difficult, but these women seem determined.

These small children take to the slopes. Skis built the Norwegian way were long and without edges. Turning and stopping were nearly impossible. Early skiers used one pole to help steer and slow their skis. The girls look like they are wearing something on their legs to keep them warm while skiing in the dresses they were required to wear in the day.

This image gives a good perspective on the length of the heavy jumping skis. Truckee jumpers included Tony Besio, Bud Campbell, Frank Titus, and Bob Bowers. Professional jumpers who performed in Truckee included Sig Ulland and Roy Mikkleson. In addition to the jump, the area's ski run had a 2,000-foot incline.

Shown is a skier making a smooth landing under the ski jump. The Truckee Ski Club, the first ski club on the West Coast, organized jumping and cross-country races. During the winter carnival, the teams would compete. Other events during carnival included basketball, baseball, and football games, boxing matches, running races, and a greased-pig contest.

The ski jump at Hilltop was a screamer. The construction of the 140-foot scaffold structure was overseen by professional jumper Lars Haugen. There were several Truckee jumpers who were awarded state recognition. In 1932, Earl Edmunds won the state title. The popularity of skiing took off and ski jumps began popping up in surrounding areas.

Sled dog racing became very popular in Truckee during the winter carnival. Here, a sled team races to the finish line through Brickelltown. Racecourses included starting points such as Tahoe City and Hobart Mills. The races almost always finished in Truckee. In 1915, Jack London made an appearance at the carnival's sled dog race.

Using the pullback lift made from the old donkey engine and reclaimed cable, toboggan riders could enjoy the almost half-mile thrill without worrying about having to walk back up the hill. The pullback lift could possibly have been the first mechanized lift system in the country. A rope tow was built at a ski area on Donner Summit only a few years later.

Hundreds of spectators line up along the sled dog route as the first competitor, Harry Kennedy, comes out of the chute. In 1928, the Sierra Dog Derby Association was formed after the popularity of dog sledding spread from Alaska to the lower 48 states. The annual dog derby went from Tahoe Tavern on Lake Tahoe to Truckee, a distance of about 30 miles.

The toboggan run on Hillside was long and fast. With grooves cut in the snow, toboggans had quite a run. Eventually, an ice pavilion was built at Hillside. It measured 300 feet by 300 feet and was made entirely of packed snow. The walls at the base were 12 feet thick.

Winter recreation spread past downtown Truckee during the winter carnival in 1919. Sleigh rides to Donner Lake became popular. Once out near Donner, people could visit the new Pioneer Monument dedicated to the Stephens-Townsend-Murphy Party, better known as the Donner Party.

Donner Lake was a popular place for recreation. As early as 1874, people seeking a fun time headed to the lake to fish and sightsee. This pleasure boat, powered by steam, was used for tourist excursions around the lake, which measures 2.7 miles long and just over half a mile at its widest point. Donner Lake continues to be known for its excellent trout and kokanee salmon fishing.

Old Man Cory ran the Donner Lake House along the wagon road that would ultimately become the Victory Highway. A popular stop for travelers, Cory was a one-stop outfitter, providing everything from beer to boats to campsites and a watering hole for horses. Another popular stop was Pollards Lake House, lost in a devastating fire in 1870.

Fishing wasn't only popular in the summer. When icemen had a chance to take a break from the harvest at Boca, they headed upstream to where they could catch rainbow and cutthroat trout. By 1871, over fishing was already seen as a threat to the survival of the area's fisheries. There were no rivers or lakes safe from the demand for Truckee fish by the restaurants in San Francisco and Sacramento.

The Lahontan cutthroat trout was the most popular catch in Sierra. It was the largest fish and the most flavorful, which would ultimately lead to the species demise. In 1871, laws were instituted requiring only hook-and-line fishing in the Truckee River. Mills and ice companies were required to protect the species by building fish ladders at their dams.

Mary Zunino, whose family owned the shoe store in downtown Truckee, strings her fishing rod before heading out to one of the area's fishing holes. At Donner Lake and Independence Lake, people fished for the lake version of Lahontan cutthroat trout known as silver trout. In Nevada, at the other end of the Truckee River, the Paiutes were fishing the ancient cui-ui fish in addition to cutthroat trout.

The area provided great hunting as well as fishing. Here, hunters at Schaffer's mill yard show their catch of rabbits and ducks. With the area's lakes, rivers, and meadows, there was plenty of game to hunt in the area, and there were several butchers who would gladly dress the meat if needed.

Camping at the lakes surrounding Truckee was a popular family activity. This family from Nevada has set up a quick camp not far from a road, possibly at Boca. During the economic slump of the 1920s, camping provided an inexpensive family activity; and with the outdoor playground that is the Sierra, the opportunities were almost endless.

Charlie Chaplin wanted most to be remembered for his 1925 movie *The Gold Rush*. Although the movie is based in Alaska, most of the snow scenes were filmed in Truckee in 1924. The movie cost $923,000 to make and grossed over $4 million at the box office, becoming the highest grossing silent comedy of all time and the fifth highest grossing silent film in movie history.

Actor William S. Hart, who gained stardom in 1914, filmed Alaskan westerns in Truckee. The railroad made it easy for Hollywood to take advantage of the Sierra backdrops instead of having to film in British Columbia. The railroad was able to accommodate just about any shoot—hauling crews, actors, props, and camera equipment.

The Minstrel Club consisted of singers, circus performers, dancers, and other entertainers. Shown here in 1919, the club had many members. They performed in Truckee's theaters for many years, entertaining town folk, as well as the many visitors who came to Truckee from San Francisco and Nevada. They were a popular troupe to watch.

Members of the Minstrel Club are pictured in blackface at Truckee's Capitol Theatre. As early as 1830, it was common for white people to perform in blackface. At first, actors used burnt cork to blacken their faces, but eventually they switched to shoe polish or grease. To modern sensibilities, of course, this racist relic of entertainment history is unthinkable.

This parade marches toward Brickelltown on July 4, 1908. Parades were popular in Truckee. The townspeople came out to show their patriotic pride. The police, fire brigade, children, acting troupes, and other organizations marched regularly. There was also a winter parade during winter carnival.

The Truckee police department marches in a Fourth of July parade, displaying their paddy wagon. Somewhat more civilized in the early 1900s, Truckee still had its share of characters, especially as the economy turned sour and men were left jobless. This parade makes its way past the west end of the downtown core.

It seemed that every community had its own band. The Truckee band performed at parades and ceremonies. Boca and Hobart had bands, but the best-known band in the area was most likely the Nifty Band. Changing names over the years, the Nifty Band hosted an annual family picnic at Donner Lake.

The Nifty Band, seen here in blackface on Church Street, started a campaign in 1904 to raise funds for the construction of a bandstand in downtown Truckee. P.M. Doyle, the first to donate, gave $50. Every Sunday, the Nifty Band, later called the Eagle Band, gave free, open-air concerts throughout the summer.

The Isis Theater was one of three theaters in Truckee. In 1915, William Rapp and Bill Englehart returned to Truckee after selling a theater in Watsonville. In 1916, the Isis installed a new operating room coil to provide steadier and brighter pictures. With better technology, the theater began showing three movies a week.

Truckee wasn't immune to having its men sent to war. Red Cross nurse volunteers are pictured here welcoming troops that were arriving in Truckee by train. In 1917, the Red Cross had more than 5,000 volunteers supporting troops and their families as the war wrapped up and those who were part of the war effort began to return to the States. The volunteers seen here are standing in front of the Fior D'Italia Hotel on West River Street.

Eight
GOING MOBILE

For many years, "Truckee or Bust" summed up the get-to-it attitude of travelers wanting to make it to the Sierra. With an almost 1,000-foot elevation gain from Truckee, the two-and-a-half-mile trip to the top of Donner Pass has never been an easy feat on foot or on bicycle.

James McIver, Truckee townsman and dairy farmer, had what he called a "go devil," a precursor to today's snowmobile. Part plow, part sled, and part tractor, it provided an easy means of getting around in the Truckee snow. Gasoline powered, it moved effectively through the snow.

Automobile caravans became popular when the Highway 40 route over the summit was improved. Beginning in 1910, driving clubs upped the ante and started an annual endurance tour from San Francisco to Truckee. The roads were dusty, so the drivers kept their cars a safe distance from each other in order to see the windy roads.

With the lack of improvements on the road, early car trips over Donner Summit were not easy. Following the old Dutch Flat–Donner Lake Wagon Road, the highway was later upgraded as a transcontinental highway. As US Highway 40, it connected New York City with San Francisco. The route was determined in 1922.

Highway 40 ran along Donner Lake and up to Donner Summit. The road was popular with visitors looking to enjoy the lake. Several resorts, opened in the late 1800s, expanded and became destinations. Gas stations began popping up in the gateway area, two miles west of downtown Truckee.

With Donner Lake as a backdrop, a car navigates the top section of Highway 40 just shy of the summit. Without guardrails, this two-mile trek was treacherous but welcomed once automobiles were widely used. Later, an overlook would allow drivers a chance to pull over and take in one of the most scenic views in the country.

Before plows were invented, the Dutch Flat–Donner Lake Wagon Road had to be kept open during the winter. Not only did the route need to stay clear for the transport of goods, materials, and people, but also because it ran parallel to the railroad. Workers were regularly called to maintain tracks and to clear tunnels of wreckage, requiring the road to stay open as much as possible regardless of the season.

The invention of the sno-go was critical to keeping the pass open. In the years preceding the completion of Interstate 80 in 1960, the only route over the summit was Highway 40. The sno-go made snow removal possible, as the blowers could send the snow up and over the banks already formed, solving the problem of where to put it.

These photographs show Highway 40 both before and after the Rainbow Bridge was installed. Established in 1913, the first name of the route was the Lincoln Highway. In 1921, the Highway 40 route was named Victory Highway. The bridge made travel easier through this windy section of canyon. The bridge was built with a 360-foot-radius curve above the span, which lessened the

18-degree slope in this area of the road. The proposed cost of the bridge was $26,000, but due to design changes and additions it ended up costing $37,304.32 when completed in 1926. In 1993, the state spent $1.6 million to restore the bridge to its original splendor.

Once the roads were cleared, travel was somewhat easier getting up and over Donner Summit. After Highway 40 was completed, the route was well maintained. The snow banks acted as a welcomed safety device, providing a natural guardrail for cars heading east over the summit in the winter. With Interstate 80, there is no longer a reason to keep Highway 40 open in the winter.

The Rainbow Bridge was dedicated in 1925 after two years of improvements made by the state. The Bureau of Public Roads built the bridge with the help of Forest Service highway funds because the Forest Service owned the land and needed to facilitate transportation of lumber to surrounding mills. Charles McGlashan is seen here at the dedication.

The enormity of the bridge project is given perspective in this photograph. Materials used in the construction of the bridge were mined from Donner Lake. Sand and gravel were moved up the highway and mixed on-site. To ease the weight carried by workers hauling the concrete in wheelbarrows, construction on the bridge moved downhill from west to east.

THE HOTEL ON THE SUMMIT 139

The Dutch Flat–Donner Lake Wagon Road and the highway that followed provided hoteliers plenty of opportunities to feed and board visitors traveling the route. The Hotel on Donner Summit had a tunnel (similar to the railroad snow sheds down the road) leading up to the entryway to shield the doors from the drifting snow. Braces were used to help support the walls after many feet of snow built up on the hotel's roof.

Bibliography

Barrett, Doug. "A Look at One of Truckee's Forgotten Murders." *Sierra Sun*, December 31, 1981.
Coates, Guy. "Truckee's 'Uncle Joe.'" *Sierra Sun*, December 15, 1994.
Donnelly, Florence. *The Paper Mill at Floriston in the Heart of the Sierras*. 1952.
"Eagle Band Will Give a Picnic." *Truckee Republican*, August 4, 1906.
Edwards, W.F. *Tourist's Guide and Directory of the Truckee Basin*. 1883.
Fire & Ice: A Portrait of Truckee. Truckee, CA: Truckee Donner Historical Society, 1994.
Hansen, Richard. "Truckee Basin's Ice Age." *Sierra Heritage* (January 1994): 40–42.
"How the Crystal Product of the Sierra Is Gathered—An Interesting Process." *Truckee Republican*, February 19, 1887.
Meschery, Joanne. *Truckee: An Illustrated History of the Town and Its Surroundings*. Truckee, CA: Rocking Stone Press, 1978.
Richards, Gordon. "Truckee's Icemen Loved the Cold Weather." *Sierra Sun*, December 10, 2004.
Smith, Jim. "Sierra Crossroads." *Sierra Sun*, March 28, 1996.
Thompson and West. *History of Nevada County, California*. 1880.
Wilson, Richard Clayton. *Sawdust Trails of the Truckee Basin: A History of Lumbering*. Nevada City, CA: Nevada County Historical Society, 1992.

DISCOVER THOUSANDS OF LOCAL HISTORY BOOKS FEATURING MILLIONS OF VINTAGE IMAGES

Arcadia Publishing, the leading local history publisher in the United States, is committed to making history accessible and meaningful through publishing books that celebrate and preserve the heritage of America's people and places.

Find more books like this at
www.arcadiapublishing.com

Search for your hometown history, your old stomping grounds, and even your favorite sports team.

Consistent with our mission to preserve history on a local level, this book was printed in South Carolina on American-made paper and manufactured entirely in the United States. Products carrying the accredited Forest Stewardship Council (FSC) label are printed on 100 percent FSC-certified paper.

MADE IN THE USA